JOHN CONSTABLE

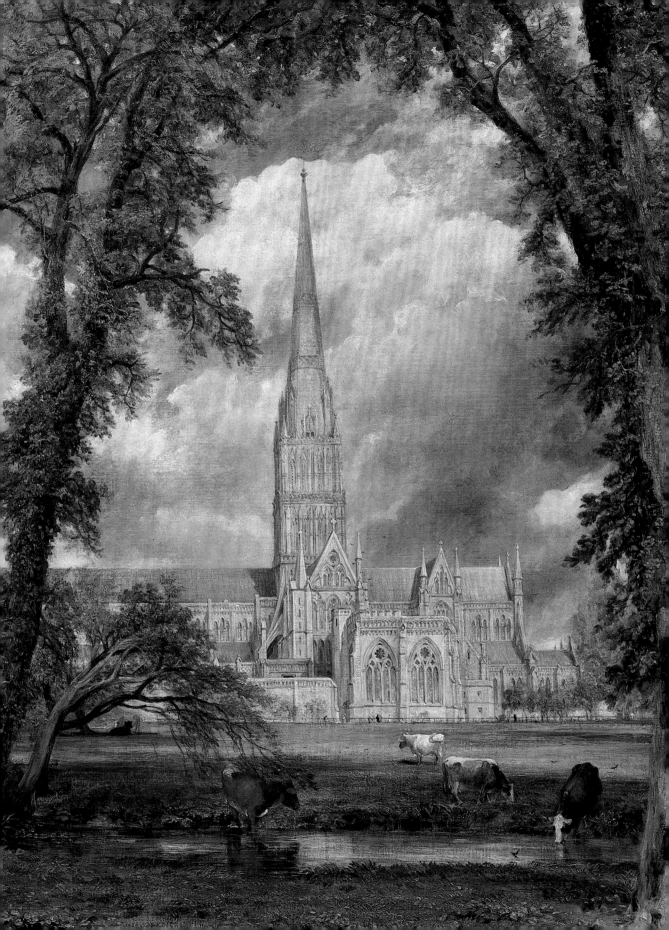

JOHN CONSTABLE

BRITISH ARTISTS

WILLIAM VAUGHAN

TATE PUBLISHING

Designed by Webb & Webb
Colour reproduction by DL Imaging Ltd, London
Printed in China
Front cover: *The White Horse* 1819 (detail of fig.42)
Frontispiece: *Salisbury Cathedral from the Bishop's
Grounds* exh.1823 (detail of fig.57)

Measurements are given in centimetres,
height before width.

For Judy Vaughan

CONTENTS

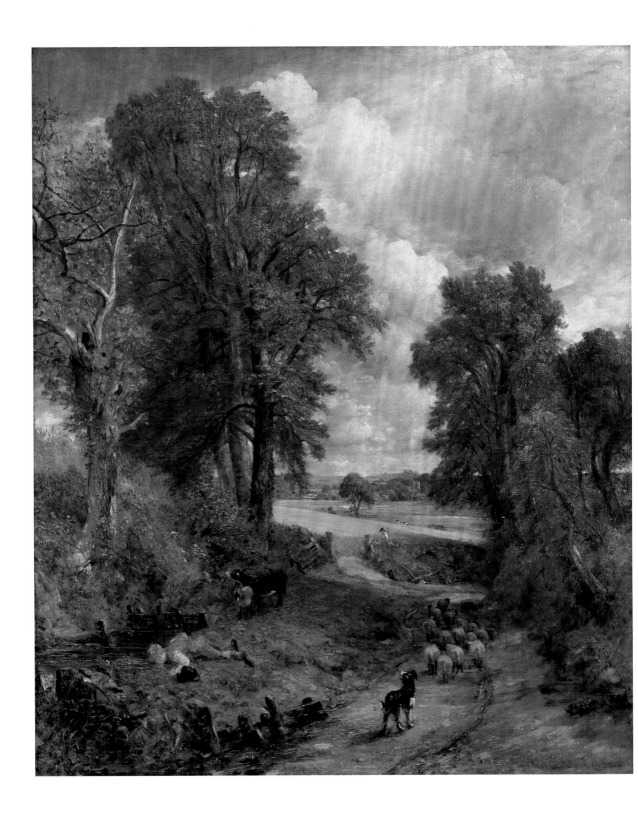

1 INTRODUCTION: IN CONSTABLE COUNTRY

'O no, this is only fields!'[1]

THE SPEAKER WAS MINNA, eight-year-old daughter of
the painter John Constable. In 1827 she was being taken to see the Suffolk
countryside, previously known to her only from such celebrated pictures
by her father as *The Cornfield* (fig.1) and *The Hay Wain* (fig.2). Her
disappointment in finding that this place of legendary beauty was 'only
fields' should be a lesson to us. It is too easily assumed that 'Constable
country' – as it was called already in the artist's lifetime – really did exist,
that the charming summer scene of a country lane with strolling sheep
and a boy lying down to drink in *The Cornfield* was a true and faithful
representation of the surrounds of the village of East Bergholt from which
the painter came. It never was. The vision lay in the paint.

It is perhaps the fate of every famous artist to be known first and foremost by a
myth. Van Gogh remains for ever the self-mutilating madman, Picasso the sex-
crazed womaniser, Rembrandt the suffering ostracised genius. Constable's legend
sees him as the authentic chronicler of the English countryside. Together with
his contemporary Turner, he is the leading light of British landscape painting
at its greatest moment. But whereas Turner is a painter of protean variety,
covering every style and subject then available – from the wildest storm to the
quietest calm – Constable sticks to a single theme, that of his native scenery.

1
The Cornfield
1826
Oil paint on canvas
142.9 × 121.9
National Gallery, London

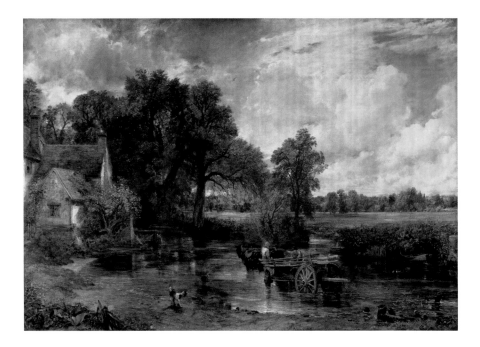

No picture has done more to promote this view than *The Cornfield*.
In it we are shown a fresh summer's day, with fleecy clouds and stately
trees. Fields stand thick with corn and sheep are safely herded with the
minimum of effort by the local inhabitants. Hanging in the National
Gallery since 1837, the year of the artist's death, it has been taken by
generations as living proof of the existence of an English arcadia. In
1996 an exhibition was held at the National Gallery of tributes to the
picture made by members of the public who had a special affection for it.[2]
Time and again the contributors stressed the appeal of the work's rural
tranquillity and its 'Englishness'.

This image of Constable's work has also been reinforced by the image of
the artist given by his first and greatest biographer, Charles Robert Leslie.
Published first in 1843, Leslie's *Memoirs of the Life of John Constable,
R.A.* told the compelling story of a fine upstanding countryman, 'the most
genuine painter of English landscape', who had struggled bravely all his
life against prejudice to gain recognition for his truthful mode of painting.
A close friend of the artist, Leslie's account gained credence from being
based on extracts from Constable's own letters and other writings. True to
the naturalistic practice of his subject, Leslie was letting the painter speak

2
The Hay Wain
1821
Oil paint on canvas
130.2 × 185.4
National Gallery, London

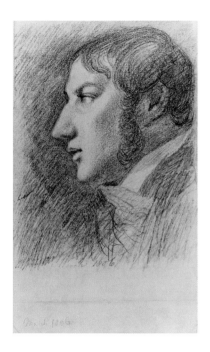

3
Self-Portrait
1806
Graphite on paper
19 × 14.5
Tate

4
Barges on the Stour with
Dedham Church in the
Distance
c.1811
Oil paint on paper
laid on canvas
26 × 31.1
Victoria and Albert
Museum, London

for himself. Selection can be deceptive, however, and not all Constable's contemporaries recognised the artist in this glowing account of his nature and mission. As Richard Redgrave, a fellow painter, observed:

> Constable has been most fortunate in his biographer, but Leslie has painted him *en couleur de rose*, and transfused his own kindly and simple spirit into the biography. The Landscape painter, though of a manly nature, was eminently sarcastic, and was very clever at saying the bitterest things in a witty manner. This had no doubt been increased by the neglect with which the would-be connoisseurs had treated his art, and by the sneers of commonplace critics.[3]

Constable – as a sharply observed self-portrait suggests (fig.3) – was in fact a troubled and complex man. Nor was there anything simple about his art. His reputation as a rural innocent should not fool us into overlooking the deeper dimensions of his work. He was, it is true, an ardent patriot and sought to make a faithful record of the scenery that he had known and loved since boyhood. Yet he knew that representing what one had experienced was no simple matter. As he once observed, the art of seeing nature was 'as much to be acquired as the art of reading the Egyptian hieroglyphs'.

Constable's art was centrally about visual discovery. It is this that gives him a key place in the grand tradition of European naturalism that ran from the Renaissance to the late nineteenth century. To achieve his way of 'seeing nature' involved a radical rethinking of the process of painting, and the creation of new methods of working – including making studies of unprecedented boldness (fig.4). It was this novel approach that brought about his first celebrity. This did not happen in England, but in France, where he received a gold medal for *The Hay Wain* (fig.2) when it was exhibited in 1824. It certainly wasn't the representation of 'Englishness' that aroused admiration in the *Salon* in Paris – it was the bold use of paint and the vivid effects of atmospherics that he achieved. Since that time his fortunes have gone up and down, but he has at all times retained the respect of fellow painters, most of whom have had no interest in him as a describer of national identity – or even naturalism – but are alive to the sense of passionate observation and daring expression that gives so much excitement to his work.

It is worth stressing this point since so much recent literature – critical as well as popular – focuses on Constable's reputation as the depicter of rural life and national identity. In recent years, following a line of argument opened up by John Barrell,[4] Constable has been attacked for misrepresenting the country people of his own days, in particular for giving an image of peace and plenty at a time when there was widespread unrest and poverty. His career spanned a time when dramatic changes were taking place in the countryside. Fuelled by burgeoning capitalism, an increasing division was occurring between landowners and labourers. Old paternalistic methods of farming were being discontinued. A poignant sign of this was the growing enclosure of former common land which prevented the poor from being able to self-subsist on smallholdings while contributing to the work of larger farms. At the time that Constable was painting his idyllic renderings of rural life, the radical journalist William Cobbett was touring the countryside and telling a very different story. Cobbett was himself a countryman, the son of a yeoman farmer, and knew the way of life he was describing as intimately as the artist did. His account, published in *Rural Rides* (1830), tells a depressing story of exploitation. As he commented, recording a journey made to Canterbury on 4 September 1823:

> In this beautiful island every inch of land is appropriated by the rich.
> No hedges, no ditches, no commons, no grassy lanes: a country divided
> into great farms; a few trees surround the great farmhouse. All the rest

5

Thomas Bewick

Vignette from 'A History of British Birds', vol.1, 1826

is bare of trees; and the wretched labourer has not a stick of wood, and has no place for a pig or cow to graze, or even to lie down upon.[5]

Constable's work contains no signs of such suffering. The artist can with some justice be taken to task for failing to acknowledge the more troubled side of rural life in his own day. The labourers in his pictures, as Barrell has observed, are usually kept at a distance. There is none of the involvement with local people that one finds in the work of other great naturalists of the age, such as the Norwich painter John Crome (fig.48) or the Newcastle engraver Thomas Bewick – who frequently shows rural poverty in his representations of the Northumbrian countryside (fig.5). The reason for this has much to do with Constable's background. Unlike Crome and Bewick, who were from the lower orders, Constable was from an upwardly mobile merchant family who identified with the landowning classes.

However, while we can rebuke Constable for 'misrepresenting' a critical aspect of rural life in his own time, we would be wrong to see this as a form of wilful propaganda. The judging of Constable by the degree of 'reality' with which he records the rural community of his time is as limiting and reductive in its way as is the popular myth of Constable

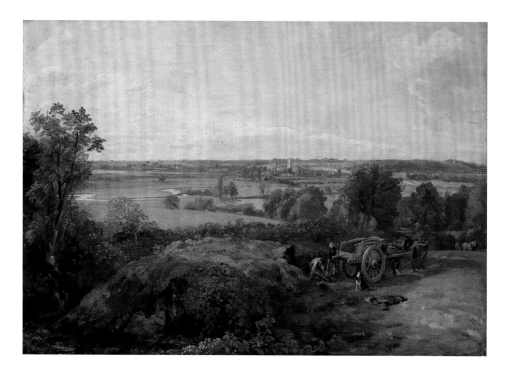

as the painter of national identity. He did not set out to provide a topography of his native countryside any more than he aimed to provide a journalistic account of life in his home village. Painting nature was for him something far more ambitious. He had a strong sense of what he called the 'moral feeling' of landscape. A wide reader of the literature, science and philosophy of his own day, he aligned his art with the work of those thinkers and investigators who saw in an understanding of natural phenomena a deeper perception of divine order and creation. It is typical of this approach that one of his favourite books was Gilbert White's *Natural History of Selbourne*, the classic study of the natural life of the countryside. Even more than Constable, White concentrated on the phenomena observed in the small village where he was curate. Like Constable, White has been taken to task by later critics for ignoring the life of the people in the village in which he lived. Yet this hardly diminishes the value of what he did give us in careful observation of the life of plants and animals and the changes of the seasons. It is worth remembering that Cobbett – as much an admirer of Gilbert White as Constable – was an acute observer of natural beauty in the countryside and recorded it as assiduously as he did the sufferings of the labouring classes. We should not ignore what Constable did give us because of what he did not.

6
The Stour Valley and Dedham Village
1814–15
Oil paint on canvas
55.6 × 77.8
Warren Collection. William Wilkins Warren Fund
Courtesy Museum of Fine Arts, Boston

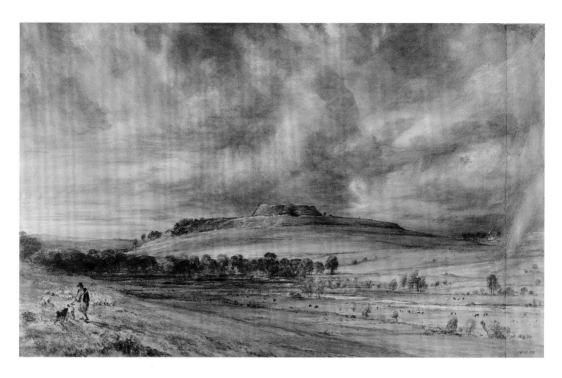

7

**The Mound of the City of Old
Sarum from the South**

exh.1834

Watercolour on paper

30.2 × 48.7

Victoria and Albert

Museum, London

Constable was not as indifferent to circumstances in the countryside as
a literal reading of his work might make one suppose. He was sensitive
to the changes that were taking place and his pictures reveal responses to
this. Constable painted rural scenes for nearly forty years and during that
time his attitude altered. The most direct records of working landscapes,
such as *The Stour Valley and Dedham Village* (fig.6), come from his earlier
years, when farming was prospering during the Napoleonic period and
when he himself still had a base in his parental home in East Bergholt. It is
worth recalling, too, that East Bergholt did not undergo enclosure until
1816, the year in which Constable settled permanently in London. The
classic images of rural tranquillity and ease come from this later period,
when he no longer had direct contact with his native village. At this point
he can be said to be painting scenes of the past, rather than of the present,
and using these in effect as a means of censuring the modern world
which has lost such tranquillity. Later on, when conditions in the country
worsened, he started painting pictures full of conflict. This is when he
depicted stormy scenes of relics of the past, such as *Old Sarum* (fig.7).
It was such work that Constable wished primarily to be remembered
for. But the public he was addressing preferred his earlier idyllic images,
accepting them gratefully as accurate records of rural life.

It is sometimes supposed that the 'painterly' Constable beloved today by connoisseurs is to be distinguished from the historical one. But this is not really the case. Constable belonged to a generation that had already been deeply influenced by the concept of original genius as it had developed in the eight-eenth century. Since the time of Gainsborough it had been believed that the sketch – either the original idea spontaneously dashed down or the direct response to the observed object (fig.4) – represented the character and skill of an artist at its most immediate and intimate. Constable himself would refer to his drawings as his 'genius' and, in a similar vein of intimacy, would often talk of his pictures as his 'children'. Yet despite this personal approach he was clear about the distinction between the spontaneous sketch and the finished work. He kept his sketches to himself and firmly refused to part with them or show them in public. People who tried to purchase them were grimly told to 'wait for his sale'. It is true that he worked to include something of the directness of his sketches into his finished work, and was criticised for this. One of the most persistent objections to his pictures when exhibited was their lack of 'finish'. At first he tried to accommodate such criticisms and aimed at a neater presentation of his work. But in the end he abandoned this and moved defiantly in the opposite direction. He became almost caricaturally insistent on roughness and notorious for representing highlights and reflections with splashes of white paint that came to be known as 'Constable's snow'. Right to the end, however, he maintained a clear distinction between the spontaneous observation and idea and the worked-out performance and considered statement of a completed work intended for exhibition or sale.

We can hardly blame Constable for subsequent misreadings of his work. Rather than do this, we should seek to understand what he was aiming to do, and why. Such knowledge can be gained only by looking at the circumstances of his life and art and tracing their development. This is what this book will attempt to do.

PART ONE: SUFFOLK

2 ROOTS: FAMILY AND EAST BERGHOLT

CONSTABLE'S CAREER can be divided into two parts. In the earlier part his life revolved around his native village. Although having lodgings in London from the time that he started studying at the Royal Academy in 1799, he returned regularly to Bergholt and kept a studio there from 1802. It was only after his marriage in 1816 that he settled completely in London and had a fully metropolitan practice. In the earlier period, while regularly sending work to the Royal Academy, he was supported by his father and by a small amount of patronage from friends and neighbours. The earlier period was one when the rural economy was booming – at least for the landowning classes with which Constable identified and for whom he worked. It was in this milieu that the artist developed his positive and celebratory view of the countryside, based on direct observation of local life and scenery, which is so different from the more complex and structured pictures of his later life.

East Bergholt, the village in which Constable was born on 11 June 1776, is a Suffolk village bordering on Essex in the valley of the river Stour (fig.8). Surrounded by low hills, the Stour meanders through a fertile terrain which had been intensively farmed for centuries. It was a man-made landscape, as was the course of the river. The latter had been made navigable in the early eighteenth

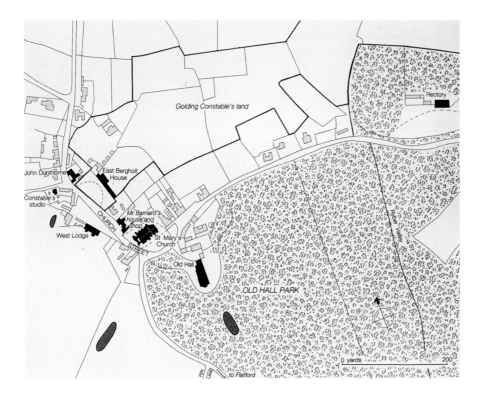

century to take the produce of the surrounding farms down to Manningtree
and Mistley on the coast, from where it would be shipped for sale in London.

8

Map of East Bergholt

Constable was born into a family who had profited from the increasing
commercialisation of farming in the eighteenth century. His father Golding
(fig.10) was of yeoman stock. In 1764 Golding inherited Flatford Mill from
an uncle and from then onwards built up a prosperous milling business.
Much of his trade was with the metropolis, and it was presumably through
his contacts there that he met, and in 1767 married, Ann Watts (fig.9), the
daughter of a wealthy London cooper. In 1774 he built a fine house (fig.11)
in the centre of East Bergholt, and it was there that he raised his family.
Altogether six children – three sons and three daughters – were born and
raised to adulthood. Of these, only two – Constable and his elder sister
Martha – married. The other four remained living together in the village.

Constable's London relatives were to prove highly important to him.
His maternal uncle David Pike Watts was a wealthy connoisseur
who encouraged him in his art. It was through other relatives, living

16

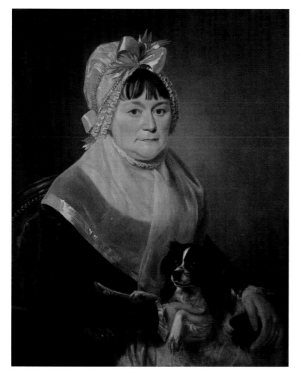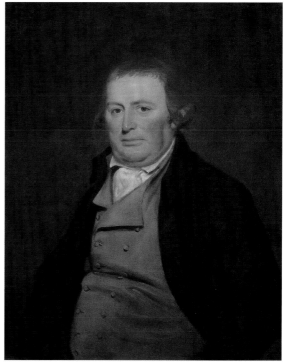

9 [above left]

Ann Constable

c.1800–5

Oil paint on canvas

76.5 × 63.9

Tate

10 [above right]

Golding Constable

1815

Oil paint on canvas

75.9 × 63.2

Tate

at Edmonton, that he first obtained the friendship and advice of a professional painter, John Thomas Smith.

The Constable family business continued to grow and prosper during the early nineteenth century. Trade in agricultural produce received a particular boost after 1806 when Napoleon's Continental Blockade meant that the country had to depend almost entirely upon indigenous food supplies. The period from that date up to the defeat of Napoleon at Waterloo in 1815 represented the heyday of British farming, in which the landowning classes and the trades (like the Constables') that did business with farmers achieved a level of wealth not known before or since.

Constable had an elder brother, Golding, who was expected to take over the family business. He himself was originally destined for the Church, and for that reason he was sent first to Lavenham boarding school and then to Dedham grammar school to receive an appropriate education. From the start, therefore, Constable was trained to become a professional man upholding moral and spiritual values, a fact that throws an interesting

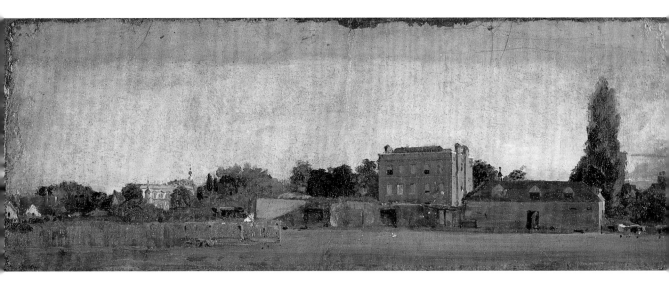

light on his later objectives as a painter. Golding Constable turned out to be something of a half-wit whose only skill (somewhat alarmingly) appeared to be shooting things. It was for this reason that in 1792, when he left school at the age of sixteen, Constable was sent to work in his father's business. There followed a difficult period, when Constable's ambition to train as a painter grew, but his father's opposition to this remained steadfast. It was only when his younger brother Abram proved capable of taking on the family business that Golding senior finally gave his permission for his second son to train as a painter. This was when John was already twenty-two.

Constable's earliest surviving work comes from the period when he was being coerced to take up his father's business. It is a signed and dated image of a windmill, incised with a knife into a board in the family mill on East Bergholt Heath, above the village (fig.12). It is a sign of resistance, of keeping the spirits up – rather akin to the graffiti scored by prisoners in their cells. Yet the fact that he should have depicted the object of his confinement indicates his complex relationship with his father and his father's business. For despite conflict there was genuine affection between the two. Constable himself had great respect for the family business – as well he might, for it provided the basis of his finances for the greater part of his life. It has been observed by

11
Mr Golding Constable's House at East Bergholt in Suffolk [East Bergholt House]
c.1809–10
Oil paint on board
18.2 × 50.2
Victoria and Albert Museum, London

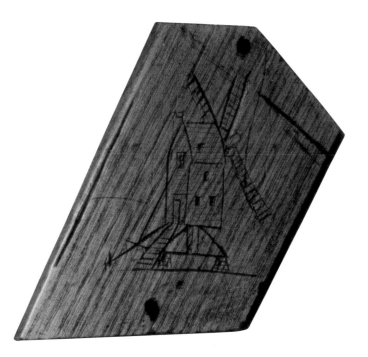

12

Incised outline of a windmill

Graffiti of East Bergholt Mill

1792

Wood; fragment from the

windmill at East Bergholt

Heath

12.4 × 8.5

Colchester Museums

Ann Bermingham in her *Landscape and Ideology* (see Select Bibliography) that Constable's deep obsession with the scenes surrounding his family's business must relate to some sense of symbolically working his father's land.

Constable's dependence on first parental and then inherited wealth throughout his career does much to explain the impression of him in the artist community. In the eyes of most working artists he was a 'gent' and was often thought of as an amateur, even after he had achieved full professional status as a Royal Academician in 1829. His financial and social position also helps to explain his own almost neurotic adherence to artistic activities that brought little profit. In this sense he forms the absolute contrast to his great rival in landscape painting, J.M.W. Turner. The son of a cockney barber, Turner was a self-made man who was already earning his own living by the age of sixteen. He would set his hand to any kind of work that was profitable – notably topographical views of fashionable tourist sites. Turner had no problems in combining such 'jobbing' work with a contiguous practice in high-minded historical landscape painting. He used his 'commercial' work to help sustain his practice in less profitable areas. Constable always found such a division to be a problem – although he did supplement his income for a time with portraiture and also painted some altarpieces for Suffolk churches.

In the 1790s, Constable cut something of a romantic figure. Well formed, he was known as the 'handsome miller' and much admired by young ladies of the neighbourhood. The knowledge of his struggle to become an artist increased his allure. As one local girl, Ann Taylor, who first met him in 1799 later attested:

> There were, too, rumours afloat which conferred upon him something of the character of a hero in distress, for it was understood that his father greatly objected to his prosecution of painting as a profession, and wished to confine him to the drudgery of his own business – that of a miller. To us this seemed unspeakably barbarous, though in Essex and Suffolk a miller was commonly a man of considerable property, and lived as Mr. Constable did, in genteel style.[1]

Despite the evident interest in him, there is no rumour of any liaison at this time. Constable was already a man of near-priggish virtue, and he was far too ambitious to form a relationship that might compromise his future career. Becoming an artist did not mean abandoning the hope of professional and social advance. When he did finally commit his affections – as he did at the age of thirty-four to Maria Bicknell – it was to a lady of significantly higher social standing than himself. There is no doubt this was a genuine love match; but the liaison was also entirely commensurate with that of a man from a trading background seeking to secure a place among the professional classes.

Yet Constable's social ambitions could not overcome his sense of dedication to his art. Despite the entreaties of his parents – and indeed of Maria – he resolutely turned his back on portraiture (the easiest form of art at the time with which to gain wealth and status) as a means of furthering his career. It was presumably his dedication to his art which also caused him to form a friendship which would otherwise have been entirely out of character. This was with the local plumber and glazier John Dunthorne (1770–1844). Something of a social misfit in East Bergholt, Dunthorne was also a painter of inn signs and local views. Constable first met him in the mid-1790s, when desperately looking for means of furthering his ambition to become a painter. Dunthorne became his first tutor in the art. He was soon to be replaced by more august figures, but the two remained close. In 1802, after he had been studying at the Royal Academy, Constable took a studio in the village close to Dunthorne's home. Dunthorne was strongly disapproved of by Constable's mother – and later by Maria. But it was not until 1816 that

there was finally a break between the two. It appears to have been some religious matter that caused the final rift (Dunthorne was a free thinker in this as in most matters). But it may also have been a necessary move before he was able to marry Maria and enter his new role as a respectable professional gentleman in the metropolis. Later Constable kept in touch with Dunthorne's son, Johnny, whom he employed as a studio assistant.

Constable's pattern of friendship seems to have been curious in other ways. Despite his evident charm and much respected character he was not the clubbable type. Early friendships with fellow students at the Academy rapidly petered out. He seemed to be able to form close friendships only with people from older or younger generations. His mentors in early life were 'father figures' such as the connoisseur Sir George Beaumont and the Academician Joseph Farington. His closest intellectual companion in later life, Archdeacon John Fisher, was twelve years younger than him; his closest professional friend and later biographer, Charles Robert Leslie, was his junior by eighteen years. Constable's wife was also twelve years younger than him. In these relationships age provided a different kind of emotional barrier, for these younger figures treated him with reverence and respect. Perhaps his skill as a letter-writer was a consequence of his taste for the distanced – though intense – friendship. Many of the figures with whom he built up such relationships lived far away. Quite possibly, remote friendship also gave him the space in which to develop his own inner resources as a contemplative artist. This may have been partly by design. For we are already in the period of the romantic image of the artist as an isolated figure drawing upon inner resources. Constable was a full subscriber to this view of the artistic temperament, describing himself once as 'living a hermit-like life though always with my pencil [brush] in my hand'.

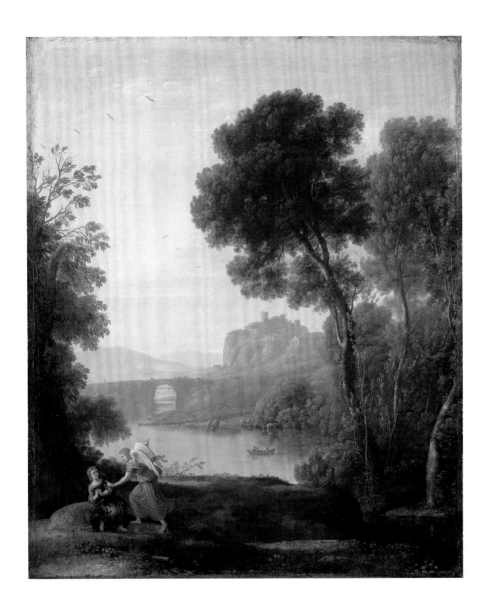

13
Claude Lorrain
**Landscape with Hagar
and the Angel**
1646
Oil paint on canvas
52.7 × 43.8
National Gallery, London

3 SEEKING A PATH

I wish not to forget early impressions. I have now very distinctly marked out a path for myself, and I am desirous of pursuing it uninterruptedly.
Constable to Maria, 27 May 1812[1]

CONSTABLE HAD DREAMED of becoming an artist since childhood but it was not until 1796, when he was in his twentieth year, that he began to turn that dream into a reality. Having started late, he continued slowly. He was twenty-six before he first had a picture exhibited in the Royal Academy, in 1802, and did not achieve any serious professional recognition until nearly a decade later.

His resolve was strengthened through meetings with two people who gave him encouragement. The first was Sir George Beaumont, a noted collector and amateur artist whom he first met in 1795. Beaumont's mother lived at Dedham, and it was on one of his visits there that he encountered Constable. As well as providing advice and some instruction, Beaumont was probably important for giving the young artist his first sight of the work of Claude Lorrain, the seventeenth-century French painter of idyllic classical scenes who was revered at that time above all other landscape painters. Beaumont owned the exquisite small *Hagar and the Angel* (fig.13), and was so fond of it that he was in the habit of taking it with him when he travelled. Whilst using a very different method of painting from the smooth style of Claude, Constable emulated his harmonious compositions. It has long been recognised that the design of the early *Dedham Vale* is based on this work (fig.14). The scenery

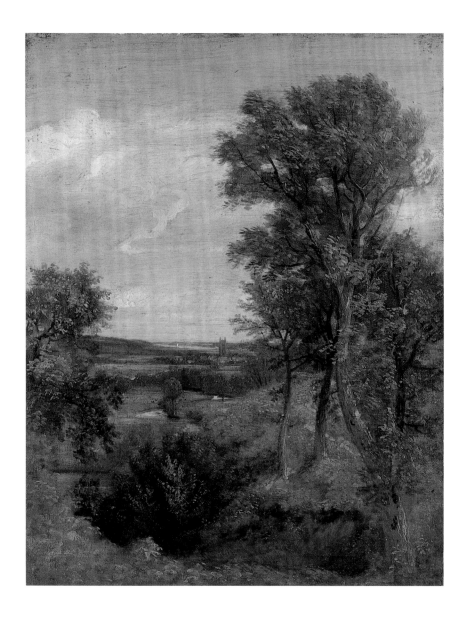

14

Dedham Vale

1802

Oil paint on canvas

43.5 × 34.4

Victoria and Albert

Museum, London

and painting method are different. Yet in their way they also show a debt to Claude. Claude was reputed to have based his scenes on direct study of the *campagna* around Rome, where he lived and worked. Constable's *Dedham* is similarly based on a terrain observed at first hand.

Beaumont may have encouraged Constable, but he did little in a material sense to aid him. Neither now nor later did he buy any of Constable's works. He became increasingly worried by Constable's development of naturalistic features that did not match his sense of the ideal. On a personal level, however, relations were cordial. Beaumont was a gentleman of the old school that Constable so admired, one of his elderly mentors.

The other meeting, with the engraver John Thomas Smith in 1796, had more practical consequences. It occurred when Constable was visiting his relatives in Edmonton. Smith was an engraver, a cockney craftsman who later became Keeper of Prints and Drawings at the British Museum but died penniless. He has a place in history for having written one of the most entertaining biographies ever penned – his character assassination of the sculptor Joseph Nollekens, from whom he had hoped in vain to inherit some money. Smith was ever full of schemes. At the time Constable met him he was preparing a book, *Remarks on Rural Scenery* (London, 1797). Constable was apparently asked to contribute some drawings of cottages, though none was used. Smith was important for introducing Constable to the 'picturesque' mode of depicting local scenery. The Picturesque movement had been gathering force in the late eighteenth century. Distinct from both ideal beauty and sublime horror, it represented a manner of appreciating the quaint and the local. The habit of making 'picturesque tours' to view such scenes in Britain became a vogue that gained a particular boost after continental travel became difficult following the French Revolution. In time Constable's naturalistic mode came to be seen as a critique of the more fanciful and formal features of the Picturesque. But it was this movement that helped him to focus in the first place on the local. Indeed, throughout his life Constable tended to see his work in terms of the Picturesque, both on account of the local nature of his subjects, and his emphasis on roughness and variety of effect – features singled out by Picturesque theorists such as William Gilpin as characteristic of the movement. In the last years of his life, when visiting Arundel on 16 July 1834, he wrote:

> the trees are beyond everything beautifull: I never saw such beauty in
> *natural landscape* before. I wish it may influence what I may do in future,

for I have too much preferred the picturesque to the beautifull – which will
I hope account for the *broken ruggedness of my style.*[2]

Certainly such ruggedness can be seen in the early picture *A Dell* (fig.15).

Smith gave Constable valuable advice about the pictorial rendering of local
effects. He advised him to people his landscapes with figures actually observed:
'Do not set about inventing figures for a landscape taken from Nature: for you
cannot remain an hour in any spot, however solitary, without the appearance
of some living thing that will in all probability accord better with the scene
and time of day than will any invention of your own.'[3] In *Remarks on Rural
Scenery*, Smith also included advice on how to give interest to the dominating
green of English scenery by varying the shades of green – a tip later passed on
by Constable to the French painter Eugène Delacroix.[4]

Smith, whilst a minor artist himself, was a key figure in promoting British
landscape in the 1790s. The growing enthusiasm for such scenery had a
political dimension. In the years following the French Revolution a need
was felt to form images celebrating 'natural' life in Britain to set against the
artificial society fabricated by continental rebels. British landscape came to
stand for British liberty. The rustic scenes of the recently deceased painter

15
A Dell
1796
Graphite and wash
on paper
40.6 × 45.7
Forty Hall, Enfield

16
Thomas Gainsborough
Hollywells Park, Ipswich
1748–50
Oil paint on canvas
50.8 × 66
Christchurch Mansion,
Ipswich Borough
Council Museums and
Galleries, Suffolk

Thomas Gainsborough took on a new role. Constable felt a particular attraction to the artist, partly because they both came from the same region. In 1799 Constable spent some time in Ipswich where Gainsborough had lived and worked in his early days. 'Tis a most delightful country for a landscape painter,' he wrote to Smith, 'I fancy I see Gainsborough in every hedge and hollow tree.'[5] He was staying at the time with the Cobbolds, a local brewing family with artistic interests, who had earlier patronised Gainsborough. Constable would have known the fine *Hollywells Park, Ipswich* (fig.16), an example of Gainsborough's early work, painted at a time when he was still influenced by the meticulous and detailed style of the Dutch seventeenth-century landscape. Constable preferred this kind of Gainsborough to the later more broadly painted ones.

Smith introduced Constable to the naturalist British landscape tradition, whilst Beaumont instilled in him the need to find a higher ideal and moral purpose in art. But it was not until February 1799 that Constable finally persuaded his father to let him study art seriously. This was when he went up to London and enrolled as a probationer at the Royal Academy.

Founded in 1769, the Academy had established itself by Constable's day as the leading art institution in Britain. The forty elected Academicians were the

elite of the profession. The annual exhibition was the artistic event of the year, where reputations were made and lost. The Academy School was the place where students were instilled with a sense of the ideal in art, through the study of antique art and the living model and through instruction on the theory of art through Discourses – such as those delivered by Sir Joshua Reynolds, the first President. It had been hoped that this would stimulate the rise of a great school of historical painting in the country, but there was little sign of this happening. By the time Constable entered the school, standards had slipped. The life class was hugely oversubscribed and morals were low. Constable soon found he had little in common with his fellow students. A brief friendship with one, Ramsey Richard Reinagle, ended when he suspected him to be engaged in producing forgeries. The sense of distance can be felt in an account of an anatomy lecture he had been to, given in a letter to Dunthorne of 8 January 1802:

> Excepting astronomy, and that I know little of, I believe no study is really so sublime, or goes more to carry the mind to the Divine Architect. Indeed the whole machine which it has pleased God to form for the accommodation of the real man, the mind, during its probation in this vale of tears, is as wonderfull as the contemplation of it is affecting. I see, however, many instances of the truth, and a melancholy truth it is, that a knowledge of the things created does not always lead to a veneration of the Creator. Many of the young men in this theatre are reprobates.[6]

Significantly, his main mentor was an older man: the Academician Joseph Farington, author of the famous diary that tells us so much about the artistic life of the period.[7] Farington provided a further contact with the British naturalist tradition, having been a follower of the classicising landscapist Richard Wilson. Although a mediocre painter, he did give Constable some instruction in landscape painting and encouraged him to develop his style through copying Old Masters, notably the Dutch painters Jan Wijnants and Jacob van Ruisdael, together with Claude and Wilson. Constable also valued him as an adviser in career matters, doubtless hoping that this *éminence grise* would help with his eventual election to the Academy.

Despite his dim view of his fellow students, and the trouble he had gaining approval for his type of landscape, Constable remained devoted to the Academy. He attended the life class diligently (fig.17). Unlike his great fellow landscapist Turner, he was tolerably good at figures. He even attempted some altarpieces and did a lot of portraits – there are nearly a hundred recorded.

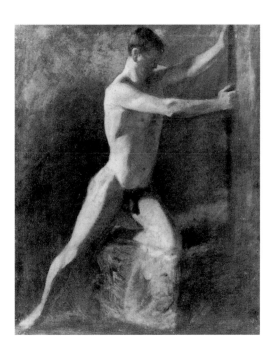

17
Academy Study
c.1808
Oil paint on canvas
60.5 × 50
Private collection

These are not distinguished, but they were good enough for him to gain commissions. There was immense family pressure for him to become a portrait painter, for this was a career that had a gentlemanly status to it, whereas landscape painting was considered a lowly pursuit – unless of course you practised it as an amateur. Perhaps this is why Constable remained so devoted to the *Discourses* of Reynolds, quoting from them frequently in his letters. He wished to give landscape the dignity and morality that Reynolds had ascribed to history painting.

In his love of landscape Constable was pursuing a personal inclination. But perhaps more than he knew he was also following a taste of the time. Fuelled by the Picturesque movement and by the nature poets of the later eighteenth century, the popularity of landscape painting was growing. In an increasingly urbanised world, the representation of nature became valued more and more as a record of the Divine. As William Cowper (one of Constable's favourite poets) put it in *The Task* (1785), 'God made the country, and man made the town.'

Undoubtedly the views of poets like Cowper helped Constable to find a moral justification for his desire to paint nature as closely and faithfully as possible. His direct experience of London also heightened in him the sense of the truth of nature as opposed to the artifice of the town. Such feelings came to the fore

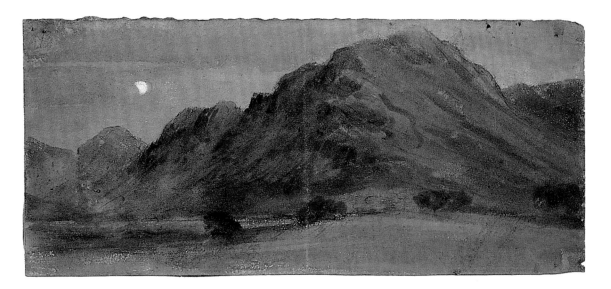

in a key letter he wrote to Dunthorne in 1802 after seeing his works exhibited for the first time at the Royal Academy exhibition:

> For these two years past I have been running after pictures and seeking the truth at second hand. I have not … endeavoured to make my performances look as if really *executed* by other men … I shall shortly return to Bergholt where I shall make some laborious studies from nature … there is room enough for a natural painture.[8]

One practical outcome of this resolve was the purchase of a house for a studio in the village of Bergholt. Slowly and laboriously he began to make studies of his native countryside. But it was to be several years before these led to major statements. Meanwhile he turned his hand to many things – topography, portraits and even an altarpiece. He also tried marine painting (making a trip on an East Indiaman in 1803) and exhibiting a watercolour of the Battle of Trafalgar in 1806. However, he remained firm in his commitment to working as a painter, turning down a job as a drawing-master at the Royal Military Academy in Great Marlow, despite the financial security this would have provided.

Perhaps the most surprising venture was a trip in 1806 to the Lake District under the sponsorship of his wealthy connoisseur uncle David Pyke Watts. Already in 1798, with the publication of William Wordsworth and Samuel Taylor Coleridge's *Lyrical Ballads*, the Lake District had become the site for a new kind of naturalistic poetry. However, this classic work had made little

18
Borrowdale by Moonlight
1806
Graphite and watercolour
on wove paper
10.8 × 241
Private collection

19

Thomas Girtin

The White House at Chelsea

1800

Watercolour on paper

29.8 × 51.4

Tate

public impact as yet and was almost certainly not a contributing factor to Constable's journey. Far more significant was the status that the Lake District had achieved a decade or so earlier as one of the key sites of 'Picturesque' scenery in Britain. Later, Leslie was to report Constable as saying that he did not like the Lakes because they were unpopulated: 'solitude of mountains oppressed his spirits. His nature was peculiarly social and could not feel satisfied with scenery, however grand in itself, that did not abound in human association.'[9] But at the time he responded to the evocative scenery positively with a remarkable group of experimental watercolours (fig.18). In these he showed signs for the first time of that profound interest in atmospherics that was to become one of his hallmarks. It would seem that Constable may have been encouraged to use watercolours for such studies by the great advances in the medium that were taking place around him, particularly by Turner and Thomas Girtin. Girtin, a precocious genius who revolutionised the handling of atmospherics, had died tragically young at the age of twenty-seven in 1802. Constable was one of many who were absorbing the lessons he had taught about capturing rapidly shifting effects of light in landscape at this time (see fig.19).

For the next three years Constable regularly showed scenes of the Lake District at the Royal Academy. For a time, it would seem, he really did consider making such subjects his speciality. When he returned to focusing on his local Suffolk countryside he brought a new sense of the changing effects of light, and a new boldness of handling, to the task. Equipped with such resources, he moved with increasing confidence along his chosen path.

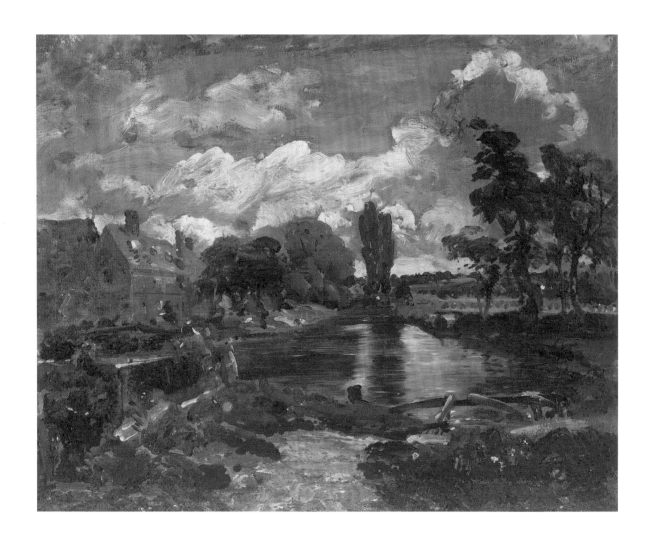

20

Flatford Mill from the Lock

1811–12

Oil paint on canvas

24.5 × 29.5

Victoria and Albert

Museum, London

4 OUTDOOR WORK

CONSTABLE'S REPUTATION today rests to a considerable degree on the large body of fresh and vigorous oil paintings that he made outdoors, in the countryside (fig.20). These were – with one or two exceptions – studies rather than finished work. However, the practice remained a central activity for him from his early years in East Bergholt until the last decade of his life.

The process itself was not new. It had been a habit for landscape painters to make direct studies out of doors since the seventeenth century. Prior to Constable's day such *plein-air* painting had been used mostly by artists working in Italy. Claude himself was reputed to have made such studies, and it was recommended by the French academician Pierre Henri Valenciennes in his influential treatise on landscape painting (1800). Valenciennes himself made admirable studies of the Roman *campagna* (fig.21) in which vivid effects of light are recorded in compositions of classical rigour.

Constable is most likely to have encountered the practice through knowledge of landscapists such as Richard Wilson, Farington's master, who had been in Rome and made such studies to invigorate their work once they had left the 'classic ground' of Italy. He would doubtless also have known the recommendation by Reynolds to paint wherever possible directly in oils.

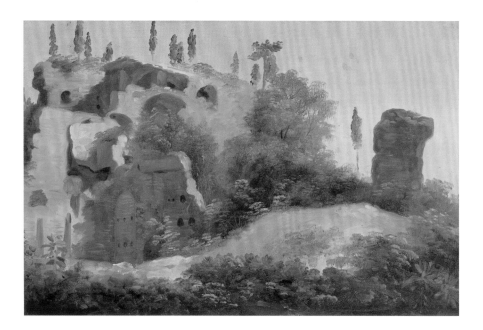

But while I mention the porte-crayon as the student's constant companion, he must still remember, that the pencil [brush] is the instrument by which he must hope to obtain eminence. What, therefore, I wish to impress on you is, that whenever an opportunity offers, you paint your studies instead of drawing them. This will give you such a facility in using colours, that in time they will arrange themselves under the pencil, even without the attention of the hand that conducts it.[1]

21
Pierre Henri Valenciennes
Ruins at the Villa Farnese
1780
Oil paint on paper
25.8 × 39.7
Musée du Louvre, Paris

Reynolds's point about achieving 'facility in using colours' was a telling one. For while making studies using drawing or watercolour will help the artist achieve a knowledge of forms, only making studies in oil will develop ways of describing them in that medium that can then be used to achieve similar effects in finished pictures.

Reynolds was doubtless thinking mostly of work in the studio. He would have hesitated, like most, from recommending too assiduous a use of direct oil painting out of doors because of the physical difficulties. Before the days of collapsible tube paints, preparing oils for use was a laborious business and transporting them even more difficult. This was probably one of the reasons why Constable set up a studio in his village. Most of the direct

oil sketches he made at Bergholt were within a few hundred yards of this building. Furthermore, they tended to be painted on small, easily transported surfaces, rather than on large canvases. In his work one can see how he faced the problems of direct oil painting. Unlike watercolour – a far more popular sketching medium which Constable had used previously, notably in his journey to the Lake District (fig.18) – oil dries slowly and so overpainting when working directly from a scene over a period of a few hours cannot to any great degree occur. This limitation encourages a more direct way of laying on areas of paint side by side, often with great vigour, as has happened in the study he made of *Flatford Mill from the Lock* (fig.20). The sky has been put on chunkily, leaving large areas of the red ground showing around its edges. In Constable's sketches it is possible to see him practising with all kinds of dabs and dashes of the brush to handle this difficult situation. It gave a special look to his work and can truly be said to be the basis of his painting method.

Constable's move to direct oil painting took place in parallel with that of a large number of other British landscape painters of the day. The watercolourist John Varley instructed students such as John Linnell and William Mulready in the practice along the banks of the Thames around 1806. The most striking convert to the method was Turner. Mindful of the difficulties of transporting oils outside the studio, Turner constructed a mobile studio in a boat. He was thus able to prepare his paints as required, and then float up and down the Thames making brilliant studies of the terrain on the banks (fig.22). These studies, begun around 1806, became the basis for a series of large-scale oils of the Thames which Turner subsequently showed at the Royal Academy.

The widespread move towards experimenting in *plein-air* studies of the English countryside can be seen as part of the general advance in interest in naturalistic studies, itself stimulated by advances in the natural sciences during the period. However, there seems as well to have been a more specific reason for the sudden outburst around 1806. This is the renewed interest in naturalistically rendered scenes of Britain as part of the patriotic enthusiasm for farming that occurred in reaction to the Continental Blockade. As has been mentioned earlier, the period between the Continental Blockade and the end of the Napoleonic Wars was one in which farming could be seen as a patriotic venture, and the emphasis on the agricultural health of the country a form of war propaganda. Turner – always astute in such matters – led the field with his large-scale celebrations of the Thames, such as his *Ploughing Up Turnips, near Slough ('Windsor')* (exh.1809) (fig.23), in which

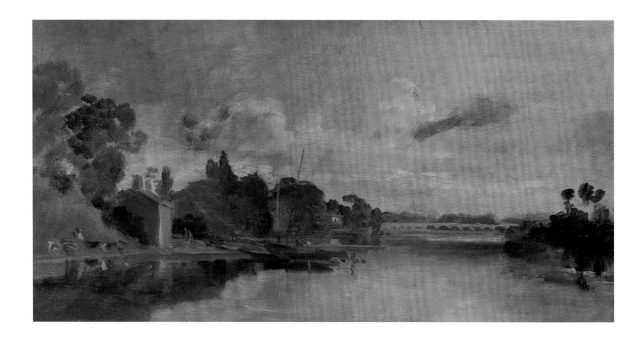

robust agricultural activity takes place in the foreground, with Windsor Castle, the seat of monarchy, looming protectively in the background.

Following a practice initiated in recent years by Barrell and Rosenthal (see Select Bibliography), such pictures have in recent years tended to be described as 'georgic'. This refers to a particular kind of verse developed by the Roman poet Virgil to celebrate the farming practice of his own day. Writing in imperial Rome, Virgil praised the good husbandry of his country as the basis of its health and success. Work hard on the land and you will be rewarded with peace and wealth was the message of the georgic. Such an idea had been emulated in the eighteenth century by British poets celebrating the growing strength of farming. Prior to this period, however, the visual arts had tended to favour the gentler, pastoral form of landscape idyll. In the period between 1806 and 1816, however, the working landscape took on a particular resonance.

Given his interest in local scenery, Constable seems to have been rather slow to catch on to this vogue. Part of the reason would appear to be the limitations in his subject matter. Suffolk was rich farming country, certainly, but it was not renowned for its scenic beauty. The Thames, which Turner painted, was by contrast one of the best-known parts of Britain and one that had obviously symbolic connections representing the country at large.

22
J.M.W. Turner
The Thames near
Walton Bridges
1805
Oil paint on mahogany
37.1 × 73.7
Tate

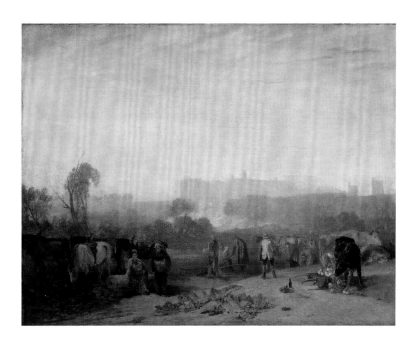

23
J.M.W. Turner
Ploughing Up Turnips,
near Slough ('Windsor')
exh.1809
Oil paint on canvas
101.9 × 130.2
Tate

Added to this, Constable seems to have taken far more seriously the need to transpose the effects of *plein-air* painting into his finished works. Very little of the effect of Turner's brilliant studies emerges in his finished pictures, which are painted with a quite different technique, using glazes applied in layers over a period of time, whereas *plein-air* painting requires direct application of paint. Turner used the process simply as an alternative method of recording and presumably to get a more vivid sense of atmospherics. After the campaign around 1805 he resorted to *plein-air* painting on only one or two occasions in later life, whereas it was to remain a constant practice for Constable for over twenty years and had a profound effect on the way he worked in the studio.

It was not until 1811 that Constable risked creating a large-scale image of his native scenery in an unequivocally 'georgic' mode. This was *Dedham Vale: Morning* (fig.24). It was a canvas that he later told Leslie had cost him more trouble than all others: he had even said prayers in front of it. In it he used atmospheric studies he had made of the view – a lane leading out of Bergholt towards Dedham – to form a harmonious composition. He recorded with particular attention the beautiful effect of the morning light which has caught the facing hills of the vale but not yet risen high enough to dispel the foreground shadows. Constable walked this lane in the morning as a boy on his way to school and must often have noted this

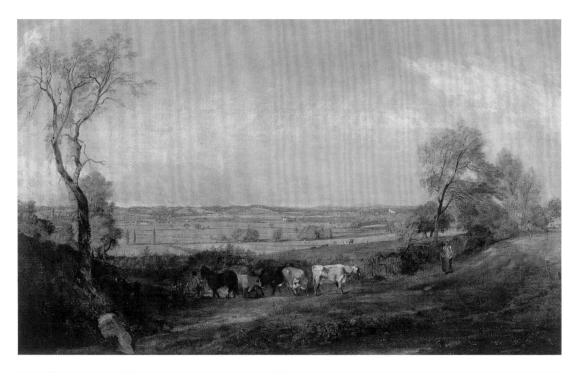

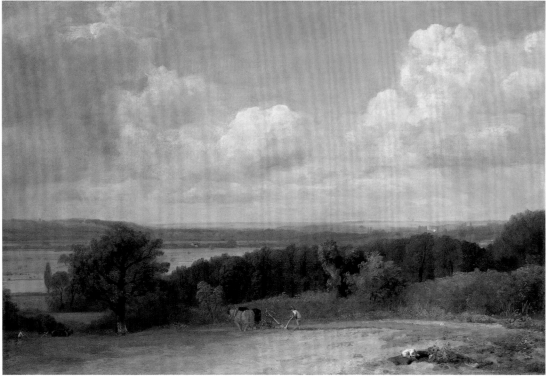

effect before he described it in paint. He can hardly have been unaware, however, of the way that Turner had already used early morning effects, as in *Ploughing Up Turnips*, to give a 'poetic' effect to a farming scene. In *Dedham Vale* he endowed the scene with a certain grandeur by showing it on a wide, panoramic canvas, flanked by trees in the classical mode. Yet the central motif is unashamedly agricultural – a herdsman bringing in cattle from the fields.

Reception of *Dedham Vale* at the Academy was indiferent and it was some years before Constable risked another grand statement. Yet at the same time the experience seems to have convinced him finally that scenes of his homeland were his *métier*. A year later, in 1812, he wrote to Maria:

> You know I have succeeded most with my native scenes. They have always charmed me & I hope they always will – I wish not to forget early impressions. I have now very distinctly marked out a path for myself, and I am desirous of pursuing it uninterruptedly.[2]

He did not, however, work exclusively on Bergholt subjects. Salisbury – which had entered his repertoire in 1811 through his friendship with the Fishers – also figured, as did some other places. But Bergholt remained the site for 'working' agricultural subjects. He had a noted success with *Ploughing Scene in Suffolk (A Summerland)* (fig.25) in 1814, a work he particularly treasured because it was the first he sold to someone he did not know personally – in this case a Clapham wine merchant called John Allnut. Doubtless the relatively small size of this work made it obtainable by this bourgeois client. But it is also intriguing as it suggests a market for the 'georgic' type of subject. Agricultural work is depicted here even more specifically than in *Dedham Vale*. As Rosenthal established, the picture shows a 'summerland', that is, a field being ploughed in the summer for autumn sowing. The 'gallows wheel' plough being used is a modern, light kind that required only two horses instead of the team of four or more, common in former days. Constable has conceded to a contemporary practice for stressing the poetic aspect of landscape, much favoured by Turner. When he exhibited the painting he included in the accompanying catalogue a quotation from Robert Bloomfield's poem *The Farmer's Boy*:

> But unassisted through each toilsome day
> With smiling brow the ploughman cleaves his way.

24 [opposite top]
Dedham Vale: Morning
1811
Oil paint on canvas
78.8 × 129.5
Private collection

25 [opposite bottom]
Ploughing Scene in Suffolk (A Summerland)
1814
Oil paint on canvas
50.5 × 76.5
Private collection

Bloomfield, native of Suffolk, was a 'peasant poet' much favoured by Constable. In imitation of Virgil's *Georgics* he emphasised the hard labour of the land (in this case 'smiling brow' presumably refers to a brow wrinkled with the stress of hard physical effort). However, he did not dwell on contemporary evils, as the fellow 'peasant' poet John Clare did. Rather he stressed the virtues of the honest hard farming life.

Constable's picture is about toil; but not too much. The hard-working ploughman is kept firmly in his place. He may be in the foreground, but he is on a pretty small scale, well overshadowed by the fine stretch of land and majestic sky that we can see above him. This diligent diminutive rustic would have caused no trouble to an urban merchant as he thrilled to the sight of other people at work in exhilarating scenery, secure in the knowledge that all must be well with the world with a farming community so productive and obedient.

Over the next couple of years Constable took his direct study of rural work further. 'I am determined to finish a small picture on the spot,' he wrote in February 1814, 'for every one I intend to make in the future.' A sign of this resolve is the sketchbook of local scenes made in the summer of 1814 (fig.26). Unlike earlier sketchbooks, these are miniature compositions, as though he was observing scenes not just to record effects but also to derive arrangements for complete pictures. As such they showed an unprecedented faith in the naturalistic process, almost without sequel until the emergence of Impressionism. Many exhibition pieces over the following decades came from this source. Perhaps because of criticisms of the looseness of his finish, and the fear that this might have been affected by the highly spirited nature of his studies, he further took the unusual step in 1814 of completely finishing two works out of doors. *Boat-Building* (fig.27) does show the greater attention to detail that this process allowed. It is carefully based on a study drawing and shows the dry dock of his father's own land, where a barge is being constructed for the corn business. What is striking is the way in which in the finished work the men shown in the sketch have all but disappeared, leaving only a small child and dog in the foreground. Once again this emphasises the work but not the worker. The other picture (*The Stour Valley and Dedham Village* 1814–15; Museum of Fine Arts, Boston [fig.6]), showing a manure heap and astonishingly painted as a wedding gift, has farm labourers in the foreground, but still safely distanced, the other side to us of the dunghill, docilely at their trade. In this case he has moved the figures back from the position they had in a preliminary study, this side of the dunghill and close to us, the spectators.

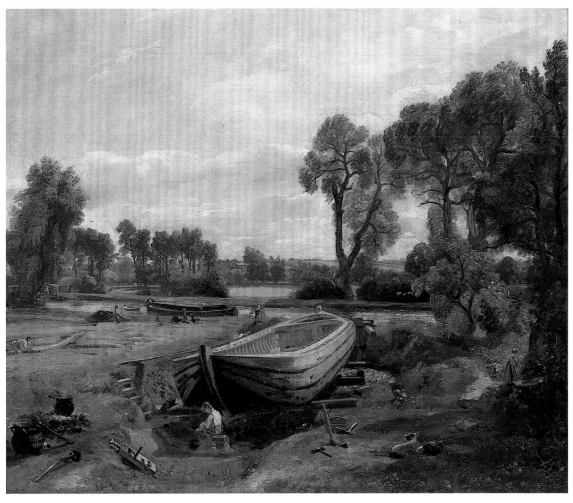

26 [left]

Boat-Building

1814–15

Graphite on paper

bound in sketchbook

8 × 10.8

Victoria and Albert

Museum, London

27 [above]

Boat-Building near

 Flatford Mill

1814–15

Oil paint on canvas

50.8 × 61.9

Victoria and Albert

Museum, London

28 [above]
The Wheatfield
1815–16
Oil paint on canvas
53.7 × 77.2
Private collection

29 [left]
Peter de Wint
Cornfield
exh.1815
Oil paint on canvas
115 × 175
Victoria and Albert
Museum, London

These small, directly studied working landscapes reached a climax with *The Wheatfield* (fig.28), a recently discovered work almost certainly painted largely on the spot. Exhibited in 1816, it appeared at a time when a large number of harvest scenes were being shown – notably the grand *Cornfield* by Constable's fellow East Anglian Peter de Wint (exh.1815) (fig.29), and the scene of a Hereford harvest by London-based George Robert Lewis (exh.1816, Tate). It has been suggested by Rosenthal that this large number of harvest scenes relates symbolically to the end of the Napoleonic Wars. With the victory of Waterloo peace had been achieved. All had been gathered in. Constable's *Wheatfield* was accompanied by another quotation from Bloomfield's *The Farmer's Boy* when exhibited at the British Institution in 1817, a year after its showing at the Academy:

> Nature herself invites the reapers forth;
>
> No rake takes here what heaven to all bestows;
> Children of want, for you the bounty flows!

This refers to the gleaning that is taking place in the foreground. Quite unusually, Constable has here prominent foreground figures. However, they are female and are objects of charity, for they are the poor who come to glean what the harvester has left behind. The image that Constable gives us here is of a traditional community, in which the indigent are also provided for. Modern farmers, by contrast, only allowed the poor to glean when the field had been well raked – leaving less to be acquired by these means.[3] The image provided by this picture was one that fitted with the one that the Government wished to promote in a period when there were already growing social problems caused by the end of war. It was also perhaps the last time such activity could be observed in Bergholt. The year this picture was painted in the fields – 1816 – was also the year that enclosure came to Bergholt, bringing with it the more mercenary practices of modern farming. Efficient modern farmers did not on the whole allow the poor to glean in their fields; they made sure that the harvest droppings were raked up to add in to the rest of their crop. Thus another sign of the old, integrated community that Constable celebrated was rapidly to disappear. 1816 was probably the last year in which Constable could have done his outdoor work in East Bergholt alongside that of the farm labourers and honestly record what he saw without having to mount a social critique on the current agricultural situation.

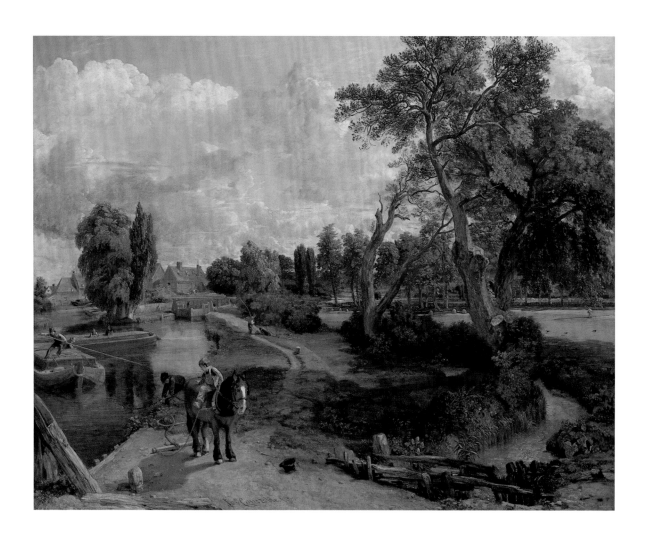

30

Flatford Mill

(Scene on a Navigable River)

1816–17

Oil paint on canvas

101.7 × 127

Tate

5 'ANOTHER WORD FOR FEELING'

Painting is another word for feeling, and I associate my 'careless boyhood'
with all that lies on the banks of the Stour. These scenes made me a painter.[1]

OBSERVATION AND EXPRESSION run together in
Constable's practice. For him they are parts of a whole, for what he sees
is what he experiences. In later life, however, the associative side became
increasingly important as he himself became physically removed from the
scenes of his 'careless boyhood'. *Flatford Mill* (fig.30) – the first major work
exhibited by him after he had settled permanently in London – marks the
transition. It is a view along the Stour leading up to one of his father's mills.
Like the 'working landscapes' of the preceding years, it shows a specific
activity. However, now the activity has moved from the fields to the river,
and has thereby become more personal to him. A towing horse is being
unhitched from a pair (or 'gang') of barges, so that these can be poled under
a bridge that is beyond the picture frame to the left. The child on the horse
in the foreground is presumably not meant to be Constable himself, but the
reference to childhood introduces a hint of nostalgia – as it does in so many
of the later 'canal' scenes. The picture retains something of the almost naive
attention to detail found in pictures finished before the motif in his last
Suffolk years – such as the views from his father's house (figs 33, 34). But
there is a new sense of overview in the way the scene is surveyed from some
height, well above the ground, from the slope leading up to the unseen bridge
on our left. It is in a sense a valedictory picture. He appears to have planned

it and started painting it in the summer of 1816. This was after his father had died and when he was gearing himself up, finally, to marrying Maria. It records the scenery of his childhood on a grander scale than anything since *Dedham Vale: Morning* of six years earlier (fig.24). It was both a recollection and the passport to his new life – professional success in London.

Constable's emotional life and artistic ambition came to a head at the same time: the whole trajectory of his courtship and his 'discovery' of his childhood scenery as the basis of his art took place in parallel. Constable first met Maria Bicknell (fig.31) – granddaughter of the vicar of East Bergholt, Dr Rhudde – in 1800, when she was twelve and he was twenty-four. However, it was not until the summer of 1809, when she paid a visit to East Bergholt as a young lady of twenty-one, that a romantic attachment developed. There were difficulties because Dr Rhudde – perhaps not surprisingly – had severe reservations about his young and highly attractive granddaughter marrying a painter approaching middle age and seemingly without prospects, who came from a somewhat lower class than his own family. This was a matter of some material importance for the Bicknells as Dr Rhudde – who was then in his eighties – possessed a significant amount of wealth, which they stood to inherit. Dr Rhudde made it clear that marriage between Constable and Maria would lead to disinheritance. Although Mr Bicknell, a successful solicitor, was a man of means himself, this prospect was sufficient to deter any encouragement of the relationship. It was not until 1816 that the two finally got married – without consent.

It could be argued that the emotional turmoil caused by this period of long and uncertain engagement provoked Constable to a deeper level of involvement with his art. On a practical level it was also a spur to him to try to pull his career together and achieve success. This challenge could also become a threat at times, for occasionally there was pressure from both Maria and his parents to jettison his landscape ambitions in favour of a more profitable undertaking – notably portraiture. Constable resisted this, and did in the end succeed in justifying the path he had 'marked out' for himself. Yet it should be remembered that, while he did achieve a degree of critical success by the end of this period, he was never able to secure the finances that Maria expected. In the end it was inheritance that made their marriage possible, not Constable's prowess as a painter.

Maria's expectations were high. When, after five years of courtship, Constable attempted to persuade her to marry him on the grounds that he could now count on an income of approximately four hundred pounds a

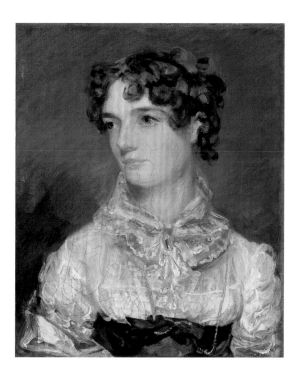

31
Maria Bicknell
1816
Oil paint on canvas
48.8 × 34.8
Tate

year, she retorted: 'indeed, my dear John, people cannot live now upon four hundred a year, it is a bad subject, therefore adieu to it.'[2] This was said, it should be remembered, at a time when an agricultural labourer could not expect to earn more than twenty pounds a year! Maria expected to live like a lady. Deep though her feelings for Constable were, she was not going to throw away her position in society through an alliance with an eccentric pauper. Equally important for her was the assertion that painting was a 'professional' activity. When Constable likened himself in 1814 to a 'hermit' and said that he shunned society and was glad that he no longer minded about achieving material success with his landscape painting, she replied:

> It appears strange to me, that a professional man should shun society, surely it cannot be the way to promote his interest ... it is certainly paying me a very ill compliment, if you like to remain single it will do very well.[3]

During this period, while insisting on remaining true to landscape, Constable was also dutifully trying to improve his professional status. It is significant that it was in 1810 – the year after he declared his love for Maria – that he stood for election as an Associate of the Royal Academy. He persisted in standing whenever the opportunity arose, only finally achieving success in 1819.

Constable also saw his relationship with Maria in terms of landscape. In this sense their meeting at East Bergholt reinforced his earlier ties. As he said, when writing in 1812: 'From the window where I am writing I see all those sweet feilds [sic] where we have passed so many happy hours together. It is with a melancholy pleasure that I revisit those scenes that once saw us so happy – yet it is gratifying to me to think that the scenes of my boyish days should have witnessed by far the most affecting event on my life.'[4] Two years earlier he had painted the view from his window in his home, looking towards the vicarage (fig.32). It is an early autumn sunrise – not a time of day ever depicted in his finished exhibition pieces. It is tempting to see a romantic interest in this boldly painted representation of a dawn.

Maria was, as her letters show, a woman of character and talent. The couple had been brought together by a shared interest in art and their love had grown as they went out sketching together – somewhat egged on, one suspects, by Constable's mother, who definitely saw Maria as a good catch. During the early years of their courtship Constable seems to have found in Maria a friend for intellectual and cultural discussion. Early in their letter-writing (which she at first tried to discourage) they confessed to having a similar interest in the poetry of William Cowper. *The Task* was one of Maria's favourite poems: she said she could read it 'for ever'. There was nothing unusual about a taste for

32

View towards the
Rectory, East Bergholt
30th September 1810
Oil paint on paper on panel
15.6 × 24.8
John G Johnson Collection,
Philadelphia Museum of Art

Cowper at that time, but this common interest did reinforce a fellow feeling for nature and the spiritual. As Constable himself put it: 'How delighted I am that you are so fond of Cowper but how could it be otherwise – for he is the poet of Religion and Nature.'[5]

Equally important to Constable was Cowper's record of daily life in the country and the interest in the local. This also coloured Constable's later love of Gilbert White's *Natural History of Selbourne*. In such work he could see a 'moral purpose' – the celebration of local nature was the celebration of the workings of the Divine:

> I am quite delighted to find myself so well although I paint so many hours – perhaps too many – but my mind is happy when so engaged – not only by being occupied with what I love, but I feel I am performing a moral duty.[6]

Apart from the example of the poets and the naturalists, Constable was also able to find a philosophical underpinning for his position. This was given him most by Archibald Alison's *Essays on the Nature and Principles of Taste* (1790), which he was reading in the summer of 1814:

> as I think it more just and its conclusions more sublime – indeed the conclusion of the last Essay 'of the Final Cause and Constitution of our Nature.' Is by far the most beautiful thing I ever read. He considers us as endowed with minds capable of comprehending the 'beauty and sublimity of the material world' only as the means of leading us to <u>religious sentiment</u> – and of how much consequence is the study of nature in the education of youth – 'as it is at least (amid all trials of society) securing to themselves, one gentle and unreproaching friend, whose voice is ever in alliance with goodness and virtue, who is alone able to sooth misfortune.' – have we not my beloved Maria both felt this?[7]

This engagement with association theory was important because it gave him an argument to defend his painting of everyday landscape. It was not the formal beauty of his native scenery that counted. It was the relation of everyday nature to religious sentiment that mattered. Association was to remain important as a justification not just for his subject matter, but also for his observation and recording of effects. As Leslie was so keen to point out later when discussing a painting of Hampstead Heath, Constable conveyed the feeling of heat in his pictures not by using 'warm' colours such as red or yellow, but by painting with

the fresh greens and blues associated in his native land with a sunny summer's day. Although such colours, viewed in isolation, would appear 'cool', they conveyed warmth when depicting a particular, carefully observed situation.[8]

Constable's last Bergholt years were marked by crisis. First came the death of his mother in March 1815. In May 1816 his father died. The small inheritance he got from this together with some improved success in exhibiting encouraged him and Maria to defy her relations and get married. They did this on 2 October, with John Fisher performing the ceremony. As they settled in London, Constable's parental home was sold, his four unmarried brothers and sisters moving to live in Flatford Mill.

During the summer of 1815, when Constable's mother had already died and a sense of change was in the air, the artist painted two remarkable views from windows at the back of the house, overlooking the garden and fields beyond (figs 33, 34). Described sometimes as a panorama, they do not in fact share the same viewpoint, being painted from separate windows at different heights. It would seem that the left-hand one, painted in July, was associated with his mother. It shows the circular flower garden that she had laid out the previous year. The right-hand one shows the vegetable garden and can be connected with his father – already ailing but not to die for another ten months. It shows riper crops in the field and was probably painted around August. The detail is precise, almost scientific. But the mood of the picture is set by the carefully recorded effects of light. Unlike the hopeful and passionate sunrise of the earlier sketch (fig.32), this shows the lengthening shadows of evening in the eastward-looking views. It is hard to avoid the idea that here the end of a period is in his mind. They must also have served him as mementoes in his years to come, after the family had quit the house.

There could hardly be a greater contrast between these meticulous, meditative studies and the bold sea scenes that Constable painted a little over a year later, during his honeymoon at Osmington on the Dorset coast (fig.35). Staying with the faithful Fisher (himself also recently married), the couple had here a brief moment of respite before moving on to the struggles of London ahead. There is ebullience and release in the wonderfully powerful clouds that ride over the artist's head and that he hastens to capture and celebrate. Perhaps he did not know this, but this new delight in clouds was to become a leitmotif for the next stage in his career. It is as though, having left Suffolk, he was now looking upwards, to more distant effervescent prospects.

33
Golding Constable's Flower Garden
1815
Oil paint on canvas
33 × 50.8
Ipswich Borough Council Museums and Galleries, Suffolk

34
Golding Constable's Kitchen Garden
1815
Oil paint on canvas
33 × 50.8
Ipswich Borough Council Museums and Galleries, Suffolk

35
Weymouth Bay (Bowleaze Cove)
October 1816
Oil paint on canvas
53.3 × 74.9
National Gallery, London

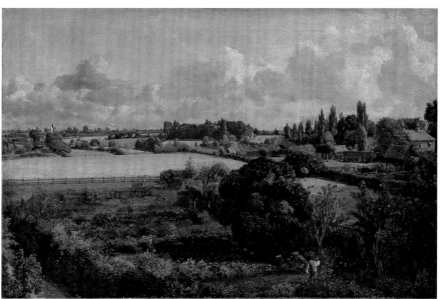

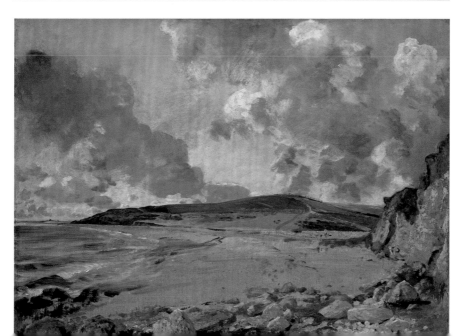

51

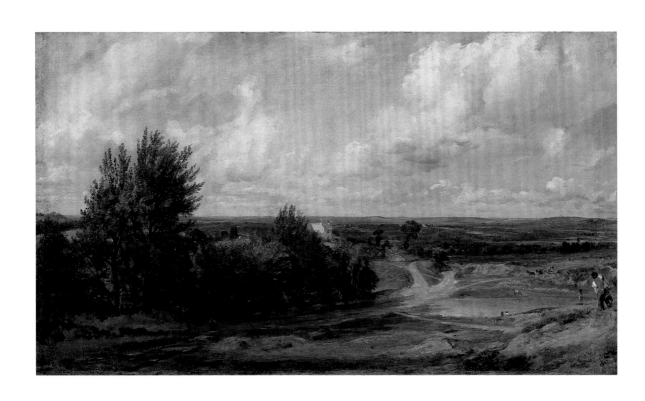

36
Hampstead Heath with the
House Called 'The Salt Box'
c.1819–20
Oil paint on canvas
38.4 × 67
Tate

PART TWO: LONDON

6 THE LONDON PRACTICE

EVEN THOUGH HE DID occasionally still produce work for Suffolk clients (as when he painted an altarpiece for St Michael's Manningtree in 1823) Constable was primarily a London artist after his marriage. The couple settled in the Bloomsbury area, then the centre of the artistic community – first in Keppel Street from 1817 to 1822 and thereafter in Charlotte Street, in the house formerly occupied by Farington, who had died in 1821. Like most professional artists at the time Constable's house was his shop as well as his studio. He kept a gallery at the front where potential purchasers could come and view works. In the early years he also ran a portrait business, having become quite adept at this line of work. While Constable's presence in London certainly helped his sales, he nevertheless still had to rely on inherited wealth for most of his income. Perhaps if he had lived more modestly this would not have been necessary. But he had a wife who expected them to live up to the standards of a professional family; and a growing brood of children (there were seven in all) added greatly to expenses. An additional financial burden was the need to find lodgings in salubrious places for Maria, whose health was never good. She spent large amounts of time in Hampstead and Brighton, fighting the tuberculosis to which she was eventually to succumb in 1828. The family rented a house in Hampstead nearly every summer from 1819, moving

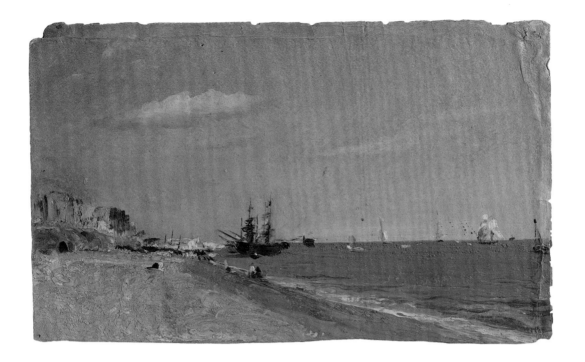

permanently into a house in Well Walk in 1827, but retaining part of their own house in Charlotte Street. Constable enjoyed Hampstead, boasting that he was 'three miles from door to door – can have a message in an hour & I can get always away from idle callers – and above all see nature & unite a town & country life'.[1] Hampstead was a common retreat for artists and writers at the time. The critic James Leigh Hunt and the poet Samuel Taylor Coleridge lived there, as did John Linnell, a fellow landscapist whose friend and visitor William Blake Constable sometimes met. Hampstead enabled Constable to continue his practice of making studies from nature on a regular basis and was particularly important for his explorations of skies and clouds (fig.36). He had a less enthusiastic view of Brighton, where the family went in the mid-1820s in the hope of providing a better cure for Maria. Describing the beach as 'Piccadilly … by the sea', he was scornful of the uncongenial mix of society and nature. His large painting of the Chain Pier, exhibited in 1827, conveyed something of this critical mood. Yet he also painted fine studies there of both the sea and life of the place (fig.37). He made other excursions to visit friends, principally to the Fishers at Salisbury, which provided another centre of study for him and was an important source of subjects for pictures in his later years. He also painted some of his most delightfully fresh studies here (fig.38).

37

Brighton Beach with Colliers

1824

Oil paint on paper

14.9 × 24.8

Victoria and Albert

Museum, London

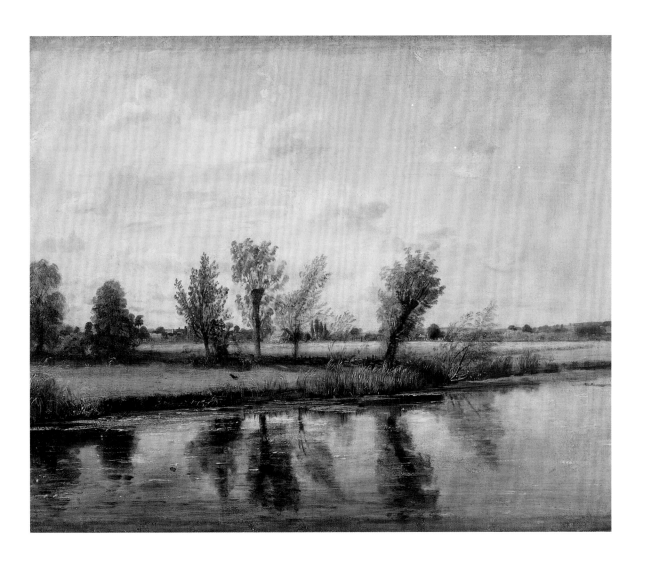

38
Water Meadows
Near Salisbury
?1820
Oil paint on canvas
45.7 × 55.3
Victoria and Albert
Museum, London

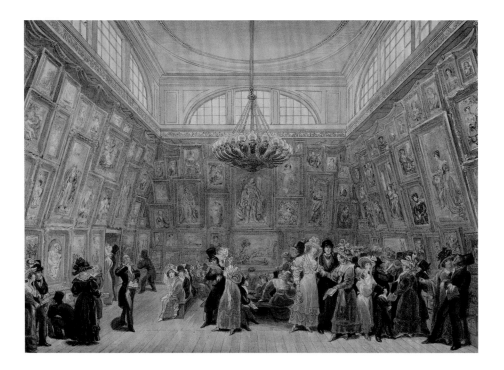

Undoubtedly the most important aspect of living in London, professionally, was closer access to the Academy. Whilst challenged by a number of other institutions – notably the British Institution and the Society of British Artists (after 1824) – it remained the prime site for exhibition and for establishing a reputation (fig.39). Constable had long cultivated friendships with leading Academicians – notably Farington, Thomas Stothard and the President, Benjamin West. These contacts eventually bore fruit when he was elected an Associate of the Royal Academy in 1819. At the time he expected that this would soon lead to full membership, but he had to wait for this until 1829. One possible reason was the election of the leading portrait painter Sir Thomas Lawrence as President following West's death in 1820. Lawrence, a master of the grandiose, glitzy portrait, disliked Constable's down-to-earth naturalism. Even when Constable was finally elected Lawrence made it clear to the landscapist that he had been lucky to be selected when there were so many promising history painters about.

Constable was not, however, quite as isolated artistically as he sometimes claimed. In the years following the Napoleonic Wars naturalistic painting came increasingly into vogue, not only in London, but also in provincial centres such as Norwich and Bristol. The leading light in this movement was

39
George Sharp
The Royal Academy Exhibition
1828
Watercolour, pen and ink on paper
18.9 × 26
The Museum of London

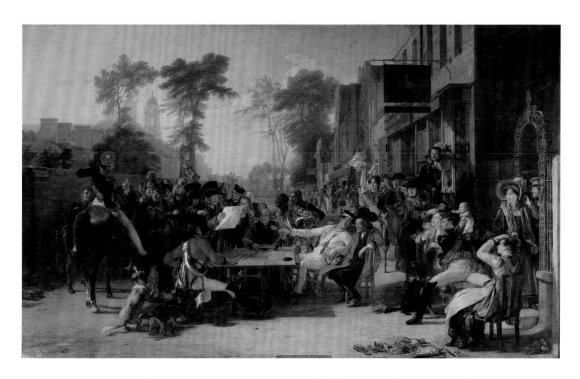

40
David Wilkie
Chelsea Pensioners Reading
the News of the
Battle of Waterloo
exh.1822
Oil paint on canvas
97.2 × 153.7
Apsley House London

the Scottish genre painter Sir David Wilkie, who had delighted audiences for decades with his scenes of simple peasant life, painted in a neat manner derived from Netherlandish art. In 1822 Wilkie exhibited *Chelsea Pensioners Reading the News of the Battle of Waterloo* (fig.40), which showed the modern London populace celebrating the great victory. This was so popular at the Academy that a rail had to be put round it to protect it. It had been commissioned by the victor of Waterloo, the Duke of Wellington himself. Wellington's wish to see the event commemorated not by a scene of military triumph but by the joyful response of ordinary people related to the current political situation.

Perhaps Constable's plan to paint the opening of a new London bridge named after the victory was motivated by similar interests (fig.41). Since Waterloo there had been widespread unrest in the country. The Conservative government – of which Wellington formed a part – sought to contain this by restrictive measures, including the Corn Laws protecting the interests of landowners and farmers, the brutal slaughter of peaceful protesters in Manchester (known as the Peterloo Massacre) and the passing of the 'Six Acts' repressing personal liberties. Eventually, by the end of the decade, a series of reforms – including those contained in the Parliamentary Reform Bill – had to be conceded. But in the early 1820s there was still a strong move

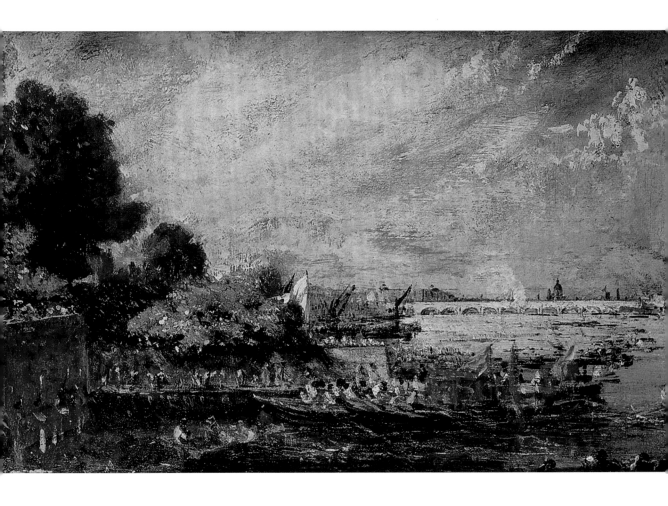

41
Sketch for 'The Opening of
Waterloo Bridge'
c.1819
Oil paint on board
29.2 × 48.3
Victoria and Albert
Museum, London

to claim that the British Constitution was 'natural', that the country's welfare depended on it, and that current unrest was nothing more than the result of the mischievous machinations of radicals who, if they had their way, would precipitate the country into horrors reminiscent of the French Revolution. In this climate naturalistic images of a joyous, peaceful populace and of rural tranquillity served to bolster official claims about the fundamental correctness of conservative policies. Many writers of the period claimed that such naturalistic art was as much a sign of national identity as were the entrepreneurial commercialism and scientific empiricism of the age. All were part of that 'independent spirit of enquiry', signalled by Protestantism, that had brought about Britain's current ascendancy. A firm supporter of the establishment, Constable was happy to have his art viewed in such a context.

While not moving forward to full Academic membership as quickly as he would have liked, Constable had the pleasure of seeing his art taken up by the French. Anglophilia ran strong amongst the new *romantiques* – including Theodore Géricault and Eugène Delacroix – who had their own agenda for using the naturalism of English painting as a stick with which to beat their own political and aesthetic hierarchies. Constable's *Hay Wain* was one of a series of British works exhibited at the Paris *Salon* of 1824, where it attracted a large amount of comment and received a gold medal. Constable – who had no idea of why the French should like his work – had hopes for a time of a new and profitable overseas market. But although he sold well in Paris through dealers for a couple of years the fad soon passed. A general economic recession in 1825 made matters worse. This was a time of great distress for the artist. It is significant that he should have undertaken his most blatant attempts at a potboiler – *The Cornfield* – at this time. But even this did not sell. Had Constable not inherited a small fortune through the death of his wife's father in 1828 his position might have collapsed altogether. As it happened he was able to spend the last years of his life in relative financial security – though with the sadness of having lost Maria in 1828.

Yet while his last years were saddened by loss, Constable was in no way a defeated person. He enjoyed a growing if limited measure of professional success. After being elected a full Academician in 1829 he played his part in the running of the Academy life school, where he was much respected by students. He had friends and supporters among the younger Academicians. It was one of these, Charles Robert Leslie, who wrote the biography of Constable that set the tone of the artist's posthumous reputation.

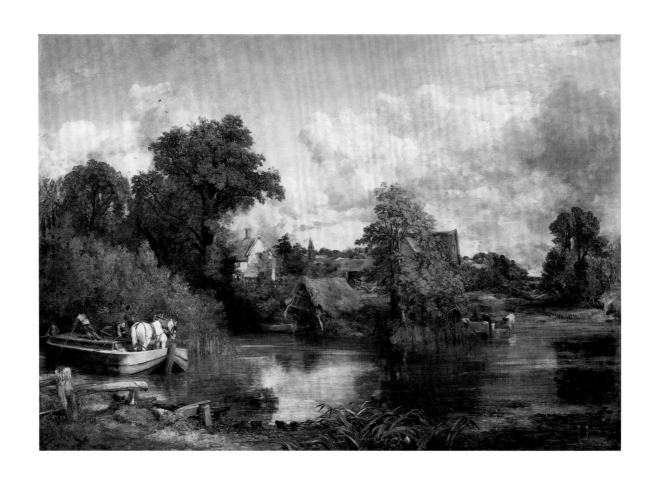

42

The White Horse

1819

Oil paint on canvas

131.4 × 188.3

The Frick Collection,

New York

7 SIX-FOOTERS

I have not been idle, and have made more particular and general study that I have ever done in one summer. But I am most anxious to get into my London painting room, for I do not consider myself at work without I am before a six foot canvas.
Constable to John Fisher, 23 October 1821[1]

IN 1819 CONSTABLE exhibited the first of his 'six-footers', *The White Horse* (fig.42), at the Academy. Later in the same year he was elected an Associate of the Academy. The two events were not unconnected. It is worth considering therefore why 'six-footers' were so important.

In the first place they showed that 'natural painture' was capable of monumental treatment. In the hierarchy of art, history painting dominated and was considered the form suitable for large-scale treatment. Size really does mean something in this context. Just as the 'epic' poem is on a different scale and has different ambitions to the sonnet, so the big picture is a weightier project than the small one. It has more matter in it, and requires a wider range of skills. It is perhaps significant that the poem Constable considered to be the greatest of all modern works was Coleridge's monumental *The Rime of the Ancient Mariner* (1798).

Although Constable had occasionally tried out large painting before (for example, *Dedham Vale: Morning* in 1811; fig.24), he had not previously attempted a canvas as large as *The White Horse*. The decision to do so now indicated a serious career move. In the first instance it brought success.

Apart from the grandeur achieved by size, there was another advantage to large-scale painting within the context of the exhibition. As has already been seen, in the crowded rooms of the Academy show it was hard to attract attention. As Leslie later remarked, *The White Horse* was 'too large to remain unnoticed' and 'attracted more attention than anything he had before exhibited'.[2]

There were, however, also serious disadvantages in painting six-footers. They were hugely expensive to make – both in terms of the cost of materials and in terms of the time taken to execute them; and they were difficult to sell. While they might have helped his reputation, they were disastrous for his pocket. Some aristocratic patrons were prepared to pay for large pictures – such as Lord Egremont, the close friend and supporter of Turner and benevolently disposed towards British art. However, even they could not on the whole see the point of treating mundane subjects on a monumental scale. The prices Constable got for his large works – averaging at around £100 – were a fraction of what Turner would expect for pictures of a similar size. It is striking that the connoisseur George Beaumont – despite his personal friendship with

43
Full-scale Sketch for 'The Hay Wain'
1820
Oil paint on canvas
137 × 188
Victoria and Albert Museum, London

44
**Full-scale Sketch for
'The Leaping Horse'**
1824–5
Oil paint on canvas
129.4 × 188
Victoria and Albert
Museum, London

Constable – never actually bought one of his pictures. Constable's naturalism, as has already been seen, appealed on the whole to a different audience – the new bourgeoisie who had neither money nor space for such grandiose works and who in any case preferred simpler and fresher forms of naturalism such as the *Hampstead Heath with the House Called 'The Salt Box'* (fig.36) that Leslie so admired. It was really only because of the loyal support of John Fisher – who bought three of the six-footers – that Constable was able to continue his sequence of large-scale 'canal' scenes. But even Fisher's means were limited, and he could not continue to support his friend indefinitely. *The Leaping Horse* simply failed to sell, and this effectively put an end to the series.

It is typical of Constable's doggedness that he should make matters even more difficult and expensive for himself by adopting the unusual and virtually unprecedented habit of making full-scale sketches for his six-footers (figs 43, 44) instead of scaling up from small studies as other artists habitually did. Quite why he did this is not known, but it would seem to be related to a desire to work out effects experimentally on a large scale before

committing himself to a final version. The relationship between sketch and finished work changed with time, the sketch becoming progressively more elaborate and bolder. This has led some to speculate that the full-scale sketch – which he retained in his studio – was the 'real' Constable and that the finished work was a sop to public taste. This seems highly unlikely, though it is clear that the later full-scale sketches show a remarkable absorption in complex pictorial processes.

Constable adopted a grand method of picture making for his six-footers, one that made conscious reference to the traditions of the Old Masters. The change can be seen by comparing *The White Horse* to the *Flatford Mill* (fig.30) exhibited earlier in 1817. Both are canal scenes showing different moments in the process of negotiating barges through the mill waters. In the *Flatford Mill*, barges are being disconnected from a horse to pass under a bridge. In the case of *The White Horse*, the horse is shown being ferried across the Stour on a barge because of the change of side on which the towpath runs below Flatford Mill. But the staging of the scene is quite different. In the first place *Flatford Mill* is on a squarer-shaped canvas with a deep foreground. This is typical of the 'working' landscapes of Constable's late Suffolk period, in which the emphasis is upon economic rural activities taking place. Although not inordinately busy, people are seen in action. Furthermore it is as much about land as it is about the Stour – with a magnificently detailed painting of the meadow beyond the towpath on the right-hand side of the picture. The sun is bright, the ambience is optimistic. Everything is in motion.

The White Horse is altogether calmer and more mediated. The shape of the canvas is wider, allowing for a broader and calmer view, less like a peep show. In fact the dimensions of the canvas are those of the 'golden section' – the harmonious set of intervals, based on the relation of the side of a square to its diagonal, used from antiquity to achieve a classic sense of proportion in the arts. The golden section is further used within the picture to determine the horizon line and also the positioning of the two principal trees on the left and right of the centre. It might seem surprising that Constable returned to this old method of achieving 'amenity and repose' that would have been known to him from classic works such as those by Claude. However, it is yet one further sign that he intended to show 'natural painture' to be capable of monumental treatment. There are historical references in the handling too; although in its clouds and trees, the picture pays debt to his other great favourite, Ruisdael. This has led to a toning down of colours; the bright greens and yellows of

Flatford Mill have been replaced by deeper, cooler hues. There are deep shadows in the distant parts. It feels later in the day, closer to early evening. Finally, the white horse strikes an aesthetic note. Why white? Fisher, with his penchant for wordplay, dubbed it 'Life and the Pale Horse'. This was a deliberate reference to Benjamin West's then famous apocalyptic scene, *Death on a Pale Horse*.[3] To those who see pictures essentially as texts to be decoded, it might appear that this was yet another way in which Constable was setting out to challenge the authority of history painting. It could equally well be a formal tribute to a far more modest but truly revolutionary picture. This is the celebrated *The White House at Chelsea* (1800, Tate) of Thomas Girtin, in which a simple view on the Thames is given a mysterious prescience by the single white house that chimes out in a low-lit scene (fig.19).

The dignity and tranquillity of *The White Horse* certainly encouraged the public to take Constable more seriously as an artist. The artifice in it might seem to be a move away from his commitment to 'natural painture'. However, it did help to stress the sense of 'moral duty' that he believed to be his larger mission. For him the grandeur drawn out of everyday nature was a sign of the benevolence of the Divine. Constable did not go in for overt symbolism: he felt this was beyond the range of landscape and would in any case have been unnatural. He remained convinced that the study and reverential presentation of nature in itself was sufficient to reveal Divine purpose.

All the six-footers of this period depict the Stour. This is why they are sometimes referred to as the 'canal scenes'. They show the Stour either being used for navigation or providing sustenance and entertainment for locals. The second in the series, *Stratford Mill* (exh.1820; National Gallery, London), represents boys fishing in a scene of ease and tranquillity. Like *The White Horse* before it and *The Hay Wain* after, it is composed using the intervals of the golden section. *The Hay Wain* became the defining picture in the series. One can see from a comparison with the sketch for it (fig.43) how the whole design in the finished work has been tightened up to form a harmonic whole. The riverbank has been smoothed to a regular curve. The boy and his horse have been removed, leaving the wain more clearly in focus.

This picture is based on studies made much earlier on, for example the small *plein-air* sketch of Willy Lott's house, c.1811 (fig.45). The house – which lay just beyond the Constable family's Flatford Mill – was named after a former resident, a tenant farmer who had lived there all his life. It was an image of

rural continuity. What Constable is doing here is revisiting and reinventing the Suffolk he had known. Like the others in the series, *The Hay Wain* was painted in London, far removed from Suffolk which he was by now no longer in the habit of visiting. He even had to send back to Suffolk to get details of the wain for the picture. A comparison of the study of Willy Lott's house with the finished picture highlights how he has aggrandised the scene, drawing features out sideways to make the whole effect more panoramic. The details may be Suffolk but the design is high art.

The original title of the picture was *Landscape: Noon*. It is important to know this to gain an idea of Constable's intentions. For he is now showing a time of day as much as an activity. The natural cycle is his main aim – and the idea of the noonday rest, the hiatus in labour. The wain is in the water to cool off the wheels after a busy morning's work. Thus Constable is able to suggest at the same time toil and repose, as though they were in a natural balance. It is this reassuring view of agricultural work – of man in harmony with the rhythms of nature – that is surely at the heart of the enduring appeal of this work. The sense of detail and close observation of light also gives it a convincing sense of reality.

It is of course worth recalling that this was not the Suffolk of the 1820s represented here, the Suffolk of rural unrest that Constable's brother Abram reported to him in his letters. It is a kind of nostalgic, timeless Suffolk, infused as much with boyhood memories as with more recent experiences.

The attention received by *The Hay Wain* greatly encouraged Constable: 'I am certain my reputation rises as a landscape painter, and that I am (as Farington always said I should) fast becoming a distinct feature in that way.'[4] When the work was shown at the British Institution in 1822 – the year after it had been shown at the Academy – it attracted the attention of Theodore Géricault, then in London to promote his *Raft of the Medusa*, and the French critic Charles Nodier. Doubtless this attention encouraged the Anglo-French dealer John Arrowsmith to visit Constable's studio and make him an offer:

I have had some nibbles at my large picture at the Gallery [the British Institution] ... I have had a <u>professional</u> offer of £70 for it (without frame) to form part of an exhibition in Paris – to show them the nature of English art. I hardly know what to do – it may promote my fame & procure commissions but it may not. It is property to my family – though I want the money dreadfully.[5]

45
Willy Lot's House near Flatford Mill
1811
Oil paint on paper
24.1 × 18.1
Victoria and Albert Museum, London

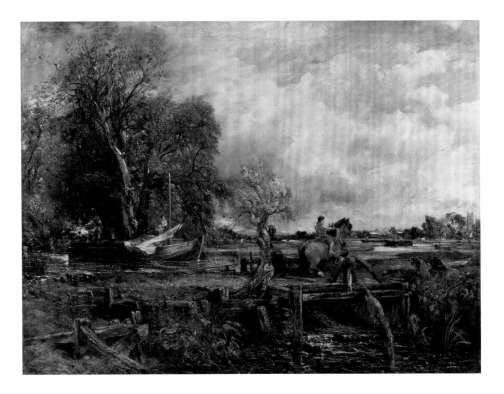

Whilst delighted by his success in France – sealed by the exhibition of
The Hay Wain at the *Salon* in 1824, Constable always remained somewhat
bemused by it. He was also disconcerted by some of the critical comments,
which were translated for him by Maria. As Constable told Fisher, one
of the French critics (probably Etienne-Jean Delecluze) had compared
his pictures to 'rich preludes in musick' and had said they are the 'full
harmonious warblings of the Aeolian lyre, which *mean* nothing, and they
call them orations – and harangues – and highflown conversations affecting
a careless ease – &C'. But as Constable added, 'Is not some of this *blame*
the highest *praise*? – what is poetry? – what is Coleridge's Ancient Mariner
(the very best modern poem) but something like this?'[6]

It is revealing that Constable should, while constructing his six-footers in the
early 1820s, have been drawn to renewing his study of the old masters. In
1823, he had an extended stay with Sir George Beaumont at Coleorton, where
he made extensive copies of Claude, Ruisdael and other masters. It seems
paradoxical that Constable should at the same time rail against the idea of
setting up a National Gallery on the grounds that it would encourage artists
to copy Old Masters rather than look at nature. All one can assume is that he

46

The Leaping Horse

1825

Oil paint on canvas

142.2 × 187.3

Royal Academy of Arts,
London

47

First study for

'The Leaping Horse'

1824

Pen, brown ink, grey

and brown wash on

trimmed laid paper

20.2 × 30

British Museum, London

saw his own study of the masters as a corrective or reference point, but not as a replacement for the *plein-air* painting that he was also continuing to do.

Having achieved a reputation as the painter of simple nature, Constable now wished to move towards a more heroic form of 'natural painture'. This ambition is clear in the last of the 'canal' scenes, *The Leaping Horse* (1825) (fig.46). The subject shows a rapid action – a towing horse leaping a cattle barrier on the towpath. Though dramatic as an image, it is hardly so as a narrative. As such it brought its own kind of challenge. Constable took immense trouble with this work, indeed he told Fisher he had never had such trouble with a painting: 'No one picture ever departed from my Easil with more anxiety on my part with it.' There was also debate between the two about getting more variety into his work. Fisher suggested moving to a different time of day, citing James Thomson's poem *The Seasons* (1726–30) as an example of giving variety in a composition. Constable declined to do this, somewhat haughtily, claiming to find variety by other means. 'I do not enter into the notion of variing ones plans to keep the Publick in good humour – subject and change of weather and effect will afford variety in Landscape … I imagine myself driving a nail. I have driven it some way – by persevering with this nail I may drive it home …' From

a formal and compositional point of view the work is one of his most exciting and sophisticated. He gradually developed the whole design, moving from the golden section format of earlier canal scenes – still evident in the first sketches (fig.47) – to a more truncated, box-like design that helps coil up the energy of the horse as it leaps. He also gradually moved the horse itself into a more prominent position, to make that leap ring out against the sky. The weather, too, became more blustery to suit the mood. It is perhaps a sign of the artist's growing involvement in what was becoming essentially a formal problem, that he should have played about with the topography of his local scene, placing a church in the distance where none was in the original site. The subject remains one of the most difficult to comprehend. There seems no reason to the outside observer why this visually exciting but quite unmomentous action on a Suffolk towpath should be invested with such drama. Perhaps it is not surprising that the painting found no purchaser.

The six-footers changed Constable's reputation; they also changed him. He was now a thoroughly urban artist. It is typical of this situation that the skies in these supposedly Suffolk scenes should have been based on studies made on Hampstead Heath in London. That part of the picture that he called the 'chief organ of sentiment' came from his contemporary experience. Thus the scenes of his careless boyhood became mediated through the feelings of the present.

This last point can perhaps be thrown into higher relief by a contrast with the monumentalisation of local scenery by a very different artist, John Crome of Norwich. Unlike Constable, Crome remained in his native environment, although he did send works to be shown in London as well as exhibiting them locally. His *Poringland Oak* (fig.48) appears to be as much a heroic celebration of his 'careless' boyhood as were Constable's views of the Stour. Yet there is an earthy matter-of-factness about Crome's large work that is utterly missing in Constable's orchestrated canal scenes. Crome celebrated a tranquil moment, with local lads bathing in the stream, giving a rare glimpse of the sensibility of the common people. He died in 1821, so it is hard to know if he would have eventually cut a figure in the London art world if works like *The Poringland Oak* had become better known there. In all probability they would not have been thought striking enough. Constable had certainly made 'natural painture' more prominent through the orchestration that he gave his six-footers. Yet the relative failure of *The Leaping Horse* suggested that he, too, was only partially successful in persuading his contemporaries that the art of the everyday should really be taken seriously.

48

John Crome

The Poringland Oak

1818–20

Oil paint on canvas

125.1 × 100.3

Tate

8 EXPERIMENTS AND IDEAS

*Painting is a science, and should be pursued as
an inquiry into the laws of nature.*[1]

IT WAS DURING THE 1820s that Constable first began to draw the analogy between art and science. Prior to this he had been more interested in poetic and moral associations. This was, indeed, the kind of issue he had discussed in his early letters to Maria, when they shared thoughts about William Cowper and Archibald Alison.

The change in direction is indicative of the development of a more theoretical approach to his art at this time, commensurate with the greater ambitions evident in the six-footers. An interest in the natural sciences was common among painters of the period. Turner, for example, closely followed developments in optics and subscribed for a time to the publications of the Geological Society. A scientific approach to representation can be found in the widespread enthusiasm for *plein-air* painting. Constable's own interest in science may not therefore be that exceptional for the time. However, thanks to the survival of so much of his correspondence, we know more about his interest than we do about that of his fellow artists.

It seems highly likely that a prime influence in this development was the encouragement of his friend John Fisher. Twelve years his junior, and the nephew of his older friend the Bishop of Salisbury, Fisher had played an

49
Trees at Hampstead
1821–2
Oil paint on canvas
91.4 × 72.4
Victoria and Albert
Museum, London

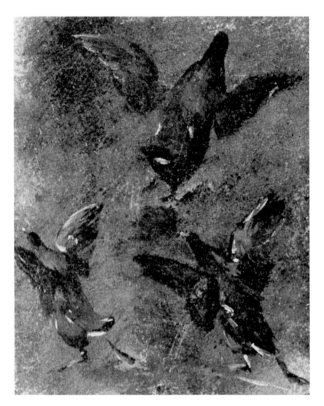

increasingly important part in Constable's life since the latter's marriage. With the exhibition of *The White Horse*, Fisher seems to have developed a new respect for his friend's artistic capabilities. He did Constable a great service by buying *The White Horse* for the full asking price in 1819. It is significant that Fisher began to keep Constable's letters only after this date. He also began to feed Constable quotes relating to naturalistic study at this time, and to recommend reading to him. During the 1820s he acted as Constable's intellectual mentor, guiding him through works on science, the arts and history.

Whilst politics was discussed less directly between the two, it was an undertow in their letters. Fisher was an establishment churchman, a beneficiary of multiple livings of the kind including the sinecure of being a prebend at Salisbury, which brought with it Leadenhall, a luxurious house in the Close. As might be expected, his politics were reactionary. He even justified slavery on economic grounds. Yet at the same time he displayed the utmost personal generosity to his artist friend and was a

50
Study of Moorhens
c.1824
Oil paint on paper
16.2 × 13.3
British Museum, London

51
Study of Trees
c.1821
Graphite on trimmed
wove paper
32.8 × 23.8
Victoria and Albert
Museum, London

lifeline to him as he was struggling in the early 1820s. Fisher may also have been a reassurance to Constable that scientific enquiry and dedication to naturalism could accord with a right-wing view of society that held that the British constitution was 'natural' and had better not be tampered with.

Yet in one sense there does seem to have been some difference in the approaches of the two. Fisher stressed the scientific side of Constable's painting, whilst Constable himself wished to make clear its moral aspects. In March 1821, when Constable was finishing *The Hay Wain*, Fisher decided to introduce him to White's *Natural History of Selbourne*, a book that he was then reading for the third time: 'I am quite earnest & anxious for you to get it, because it is in your own way of close natural observation: & has in it that quality that to me constitutes the great pleasure of your society.'[2] Constable did acquire it and remarked that 'it only shows what a real love for nature will do – surely the serene & blameless life of Mr White, so different from the folly & quackery of the world, must have fitted him for such a clear & intimate view of nature'.[3]

It would seem that virtue and the study of nature were closely combined in Constable's mind. Perhaps because of his separation from his native Bergholt he was now making intense studies of nature wherever he could (fig.49). A long stay with Fisher in the summer of 1820 – when he made a fresh study from the window – continued the *plein-air* work of earlier days. Yet, perhaps under the influence of White, he also spent more time on exact and minute study of fauna and flora, such as the spirited studies of water fowl (fig.50) and the magnificent detailed drawing in pencil of a group of trees, in which the foliage and trunks are so clearly distinguished (fig.51). Constable's love of trees was recorded by Leslie: 'I have seen him admire a fine tree with an ecstacy of delight like that with which he would catch up a beautiful child in his arms.'[4] Constable once referred to a 'tall and elegant ash' (his favourite kind of tree) as 'this young lady', and undoubtedly his deep love of trees was influenced by some kind of anthropomorphic view of them as personifications of natural virtue.

At much the same time Constable reported to Fisher a new interest in making studies of clouds. Talking of this new habit in 1821, he said he wished 'It could be said of me as Fuseli says of Rembrandt. "he followed nature in her calmest abodes and could pluck a flower on every hedge – yet he was born to cast a stedfast eye on the bolder phenomena of nature".'[5]

Once again, emotion and observation were locked together in Constable. As he later said, he regarded skies as the 'chief organ of sentiment' in a picture. Some studies of them were poetic – based on the compositional approach copied from instructors in landscape method such as Alexander Cozens, and once accompanied by poetry from Bloomfield's *Farmer's Boy*. But his most celebrated skies are the direct oil-study observations of clouds (fig.52). These may have been partly occasioned by opportunity. He was now staying regularly in Hampstead each summer on account of Maria's health. It has been speculated too, however, that he might have been responding to recent meteor-ological advances, in particular the publications of Luke Howard. Howard first published his classification of clouds – the basis of the one that remains in use to this day – in 1803. In 1820 he published *Climate of London*, in which cloud types were related for the first time to a specific urban environment, and one that would have particular relevance for Constable. There is no evidence that Constable knew Howard's work. However, he did possess a book by Thomas Forster, an amateur scientist who described Howard's classification system, and there is possible evidence of his knowledge of Howard's nomenclature in a sketch in which one such term, 'cirrus', appears to be inscribed (fig.53). It is a sign of a 'scientific' approach that he would habitually give precise

52
Cloud Study
25th September 1821
Oil paint on paper
laid down on board
21.2 × 29
Yale Center for British Art,
New Haven

53
Cloud Study Cirrus
?1822
Oil paint on paper
11.4 × 17.8
Victoria and Albert
Museum, London

records of the date and time of day for such works. Like Howard (who himself made sketches of clouds), Constable was concerned to capture the cloud formation of a particular moment and circumstance.

Constable's clouds are at once scientific and poetic. They are the expression of that combination which he envisaged in a letter to Fisher of 9 May 1823, of his great predecessor, the landscapist Richard Wilson, walking in paradise 'arm in arm with Milton and Linnaeus'. The choice is significant, not just because here a great poet and great scientist are brought together, but also because both saw their work as having a religious justification. It was, after all, Milton's intention in *Paradise Lost* to 'justify the ways of God to man'. Linnaeus similarly saw his great achievement of creating a classification system for all plants as a way of revealing 'God's great plan'. Constable felt that he had a similar divine mission in his pictures. Interestingly, at this time it seems to have been the aspect of transience that caught his attention most. As he moved away from the specific world of Suffolk he focused increasingly on atmospherics as showing the changing moods of nature. As he was later to say in the text accompanying the collection of mezzotints by David Lucas after his own works, *The English Landscape* (1833), his aim was 'To arrest the more abrupt and transient appearances of the CHIAR'OSCURO IN NATURE … to render

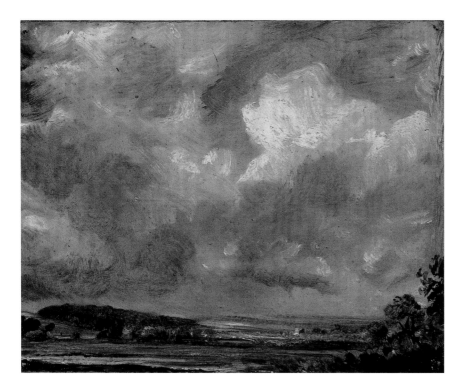

permanent many of those splendid but evanescent Exhibitions, which are ever occurring in the endless variety of Nature, in her eternal changes'.[6]

This gradual shift of perspective also caused him to take in a broader view of history. Once again Fisher appears to have given him a lead, drawing his attention in particular to the popular history of England by the lawyer Sharon Turner. On 26 August 1827 Constable wrote to Fisher: 'I read Turners History continually – for two reasons – first I think thereby of you – and its information is endless and of the best kind.'[7] Turner's views of the development of England were to be of particular importance for Constable in the late 1820s as he started to engage with subjects, largely from the Salisbury area, that touched on historical matters. Turner's popularity in Britain was based to some extent on his near-messianic view of the Anglo-Saxon race, whose current imperialist gains seemed to him to be the fulfilment of a natural destiny. Seeing the Saxons essentially as a roaming and conquering race, he claimed such behaviour was stimulated by the invigorating effect of the changeable British climate. Such an observation must have been music to the ears of the master of 'natural painture'. As will be argued in the next chapter, Constable's late major paintings display the influence of such ideas.

54
Harnham Ridge
?1829
Oil paint on paper
laid on canvas
19.6 × 25
Private collection

In his last years Constable took an increasing interest in geology: 'I must say that the sister arts have less hold on my mind in its occasional ramblings from my one pursuit than the sciences, especially the study of geology, which, more than any other, seems to satisfy my mind.'[8] For an artist who virtually never made studies of rocks this might seem a strange choice. Still, his late studies – such as that of *Harnham Ridge* (fig.54) – do show a new concern for terrain, as do his panoramic views of Salisbury and surrounds. Geology was one of the most popular sciences of the day, and Constable's own son John's interest in it in the 1830s was certainly a stimulus – as when they made a visit to Arundel in 1834: 'John is enjoying himself exceedingly. The chalk cliffs afford him many fragments of oyster shells and other matters that fell from the table of Adam in all probability.'[9]

Among Constable's own collection of books was one by Baron Cuvier, one of the most popular geologists of the day. Constable doubtless also gained satisfaction from knowing that the unfolding of vast eons of time, in which geologists were engaged, was typically taken in Britain at least as yet further proof of Divine providence and confirmation of the rightness of the rational religion of the Anglicans. It might seem, once again, that he turned to this science of the remote past as a solace to cope with the problems of the present. It was an isolation felt all the more keenly after 1832 when his younger friend Fisher died suddenly at the early age of forty-five.

Yet ultimately Constable encountered a paradox – one that Fisher had not perceived. For, however much his studies directly after nature could be seen as observations and 'experiments', the final work of art was in the end a construction that made its own statement and one that had to replace that which had been perceived. In a melancholy and despairing moment he wrote to Leslie (now his chief mentor after the death of Fisher) on 13 February 1833:

> Good God – what a sad thing it is that this lovely art – is so wrested to its own destruction – only used to blind our eyes and senses from seeing the sun shine, the feilds [sic] bloom, the trees blossom, & to hear the foliage rustle – and old black rubbed-out dirty bits of canvas, to take the place of God's own work.[10]

To this, there was no answer.

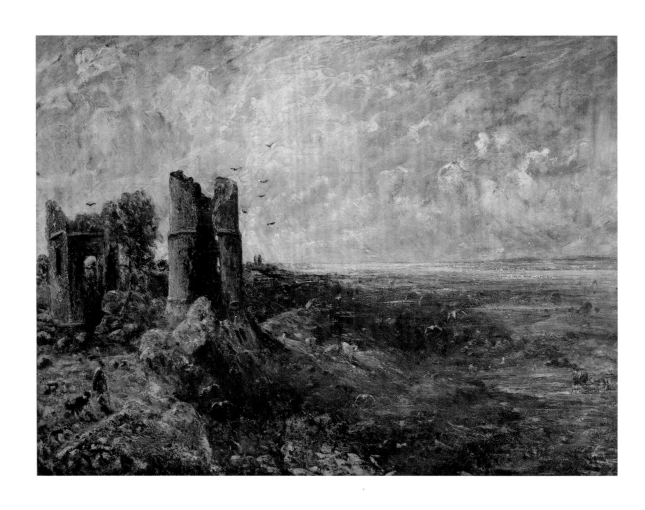

55
Full-scale Sketch for
'Hadleigh Castle'
1828–9
Oil paint on canvas
122.6 × 167.3
Tate

9 STORMY WEATHER

THE LATE 1820s brought Constable simultaneously security and collapse. In 1828 he inherited about £20,000 via his wife, which meant that his financial troubles were over. From now on he was a man of means. In 1829 he was finally elected a Member of the Royal Academy. However much this honour might have been tarnished in his eyes by the lateness of its arrival, it did secure his professional position and gave him a base from which to launch his pronouncements upon art. In this last decade of his life he worked in a systematic manner to secure his reputation – something that his wealth and academic status helped him to achieve.

Collapse came more from the personal and political sides of his life. Worst of all was the loss of Maria from tuberculosis. Worn out by her almost constant pregnancies, she succumbed in November 1828. Their marriage had been particularly close, and Constable felt the blow bitterly. 'I shall … never feel again as I have felt – the face of the World is totally changed for me,' he wrote to his brother Golding.[1] He wore mourning for the rest of his life, devoting himself primarily to the care of his children. The death of Maria was made all the harder because his election to the Academy followed it by no more than a few months. It was as though he had been denied the chance to prove himself to her fully, by achieving the status that would make him truly a gentleman. There was also a hint that his ultimate

election might have been the result of a sympathy vote in the face of his recent personal loss. Certainly Lawrence, the president – who had little respect for Constable's art – made it clear to him that he had been lucky.

Added to personal loss was the anxiety that he felt – as a traditionalist – in the face of radical political changes. The late 1820s were the time when the right-wing Government was accepting, painfully and slowly, the need to effect the constitutional and social reforms they had been resisting for so long. From 1812 until his paralysis in 1827, Lord Liverpool had been Prime Minister. Broadly continuing the conservative policies of William Pitt the Younger, he had countered protest with repressive measures. He believed firmly that the forces of 'progress' needed to be held in check for the underlying health of the country, which was maintained by the landed interest. As he reportedly put it, 'the landed interest ought to have the predominant weight. The landed interest is in fact the stamina of the country.'[2] After Liverpool had gone, cherished bastions began to crumble. In 1828 the Test Act was repealed and Catholic Emancipation was conceded in the following year: this resulted in the Anglican monopoly of public office and parliamentary representation becoming undermined. Traumatic as they were, these moves were but a prelude to an even greater event: the reform of parliamentary constituencies. This was the single greatest blow to traditionalists because it resulted in a redistribution of parliamentary seats, finally giving some recognition to new industrial towns such as Manchester and abolishing the corrupt 'rotten boroughs' which had few or no residents. Before this Bill was finally passed in 1832 it had a stormy ride through Parliament and provoked rioting throughout the country. Constable was beside himself with grief over the matter. He thought the Reform Act would 'give the government into the hands of the rabble and dregs of the people, and the devil's agents on earth – the agitators'.[3]

It is against this background that the darkening mood of Constable's later paintings must be seen. However, we should be careful not to view this just as a negative reaction. Still less should we fall into the trap of seeing the late Constable style as the result of a nervous collapse. Constable experienced grief and disturbance at this time but he did not lose his self-possession. Rather it can be seen that in these later years he developed a reasoned if critical view. In the end, like most Tories, he accepted the changes (which did not, in the event, bring about the social revolution he had feared) and addressed them in a constructive manner.

It is symptomatic of this situation that his pictures should have become more rhetorical. It was not enough to embody the harmonies of nature, as he felt in his earlier six-footers. There needed now to be a more explicit form of address. He also felt freer to use such works to say what he wanted, as he no longer had to sell his pictures to survive. One of his first responses, on hearing that his money worries were over, was to say that he 'need never feel guilty working in front of a six-footer again'.

Hadleigh Castle was the first major work that he produced after his fortunes had improved. Yet it was also the first big picture completed after Maria's death, and it is hard not to see in it an expression of personal grief. As he commented later in a letter, he felt himself to be a 'ruin' like the castle he had depicted. Although the choice of subject is a distinct break from his earlier subjects, it did originate from the same period as most of his 'canal' scenes, being based on a sketch made when visiting Hadleigh in June 1814. Even at that time he had been struck by the awesome nature of the place, writing to Maria: 'I was always delighted with the melancholy grandeur of a sea shore. At Hadleigh there is a ruin of a castle which from its situation is a really fine place – it commands a view of the Kent hills, the nore and north foreland & looking many miles to sea.'[4]

As usual, Constable worked up a full-scale sketch (fig.55) before moving to the final canvas. This sketch is so elaborate that it seems to function as the 'wilder' version of the finished work. The tempestuous paintwork, so much a hallmark of his later style, seems to go beyond representation. It is significant that it was around this time that he stopped making outdoor oil sketches. This is a picture of the mind. Perhaps the sketch remains the most personal expression of his sense of abandonment after the death of Maria. The version exhibited at the Royal Academy in 1929 is more restrained, and more hopeful.[5] The subtitle of the picture given in the exhibition catalogue is ' – morning, after a stormy night'. The clouds are still lowering, but they are in retreat. The old ruin has survived to fight another day.

Battle was resumed in Constable's next major work, *Salisbury Cathedral from the Meadows* (fig.56), exhibited in 1831. Its difference from earlier treatments, painted in calmer days, is striking (fig.57). Like *Hadleigh Castle, Salisbury Cathedral* is a stormy picture that could be seen to reflect his personal crisis. It also appears to have in it a tribute to his friend Fisher, who had been such a help in his hour of need. Fisher was, after all, a prebend of the cathedral. His

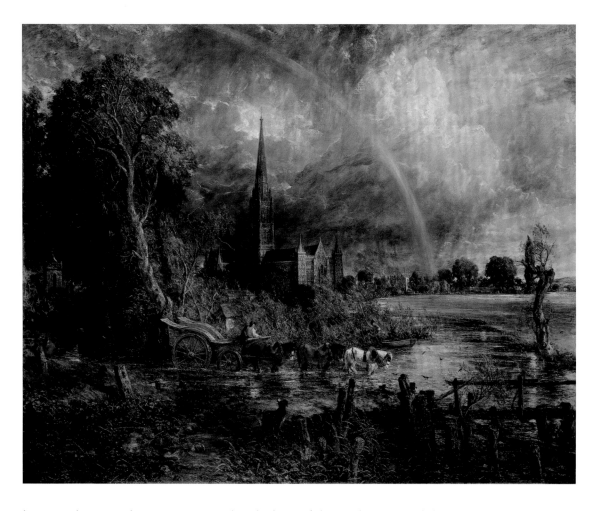

house is shown in the picture, situated at the base of the rainbow. Yet while these references give the picture a personal dimension, it seems to have a broader political message as well. As Fisher commented, it shows the 'church under a cloud'. By this time the Anglican hierarchy – of which the cathedral was an unmistakable symbol – had had to concede power to Catholics and non-conformists. The Reform Bill, furthermore, was encountering a maelstrom of conflict as it passed through Parliament. One wonders whether Constable knew too of the assault on the cathedral functionaries of Salisbury to be found in William Cobbett's *Rural Rides*, published the year before. Attacking the present incumbents for leeching on the poor, Cobbett uses the image of the cathedral as a reminder of the spiritual and caring society that he believed had existed previously in the Middle Ages. 'For my part, I could not look up at the spire and the whole of the church at Salisbury, without

56
Salisbury Cathedral from the Meadows
1831
Oil paint on canvas
151.8 × 189.9
Private collection

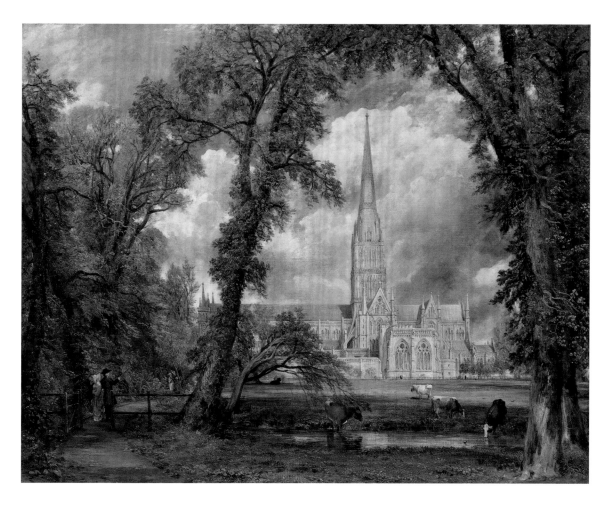

57

Salisbury Cathedral from
the Bishop's Grounds

exh.1823

Oil paint on canvas

87.6 × 111.8

Victoria and Albert
Museum, London

feeling that I lived in degenerate times. Such a thing could never be made *now*. We *feel* that, as we look at the building. It really does appear that if our forefathers had not made these buildings, we should have forgotten, before now, what the Christian religion was!'[6] Constable takes an opposing view, identifying the cathedral – as Fisher had done – with the present Anglican order. The rainbow – that traditional sign known to all Christians from the biblical story of Noah as 'God's Promise' that he would not punish mankind again as he had done with the flood that nearly exterminated the whole world – is used here to suggest the worst is over.

Salisbury Cathedral from the Meadows was exhibited before the Reform Bill was passed, and when there was still hope among conservatives that it would not become law. Perhaps this hope is what encouraged Constable to include a

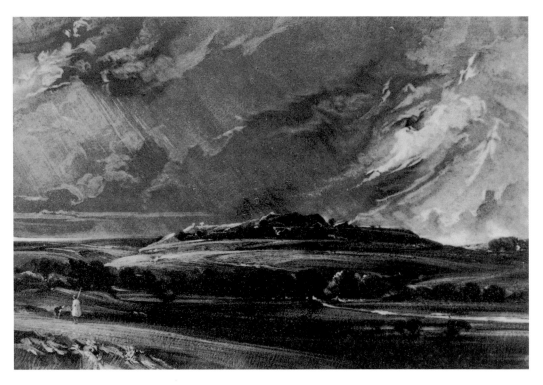

rainbow in the picture. It does not appear in the preliminary full-sized sketch. Be that as it may, Constable was inordinately proud of the finished result. He regarded it, in fact, as his greatest achievement and commissioned a mezzotint of it from David Lucas. He also exhibited it in several places in the last years of his life – at the British Institution (1833), in Birmingham (1834) and Worcester (1836). By this time he had, as he put it, 'quite got over' his despair at the Reform Act. The political outlook, after all, was not that bleak. No revolution had occurred. The Whigs were in power, it was true. However, they were now receiving many of the brickbats previously aimed at the former Tory government. In the face of the uncaring commercial world the Whigs appeared to support – for example, with the infamous new Poor Law Act of 1834 – there was growing popular nostalgia for the security and order of the 'good old days'.

It was in this climate that Constable began to publish the cycle of mezzotints by Lucas after his work. Entitled *Various Subjects of Landscape, Characteristic of English Scenery, from Pictures Painted by John Constable, R.A.*, it is now commonly known as *English Landscape*. The text in the publication made it clear that the artist was aiming at more than a retrospect of his career. He wished to provide a commentary on his native country. The

58

David Lucas after John Constable

Old Sarum

1829–30

Mezzotint

14 × 21.5

Plate from

Various Subjects of Landscape, Characteristic of English Scenery, from Pictures Painted by John Constable, R.A.,

1830–2

Syndics of the Fitzwilliam Museum, Cambridge

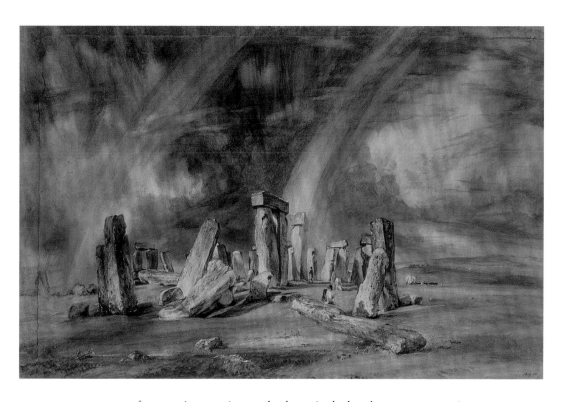

59

Stonehenge

exh.1836

Graphite and watercolour

on wove paper

38.5 × 56.5

Victoria and Albert

Museum, London

use of mezzotint, a print method particularly adept at representing texture and tonal contrast, fitted in well with his wish to capture the effervescence, the 'chiaroscuro', of nature. It is a sign of this that many of the plates are captioned with observations on time and climate, such as 'windy noon' or 'morning breeze'. Sometimes these appear to contain political allusions. His view of *Old Sarum* (fig.58) is subtitled 'Thunder Clouds'. Lawrence, on being sent a proof in October 1829, commented: 'I suppose you mean to dedicate it to The House of Commons?' Old Sarum was one of the most notorious of the rotten boroughs. Yet it had also been the seat of the first Parliament, in the reign of King John, and the place where the laws governing the medieval feudal system were passed. Constable alluded to this history in the accompanying text. He further commented that stormy weather was appropriate for the depiction of a once glorious and now destroyed place. Such thoughts also predominated in his bleak watercolour view of *Stonehenge* (fig.59), where a rainbow surmounts the oldest extant monument in Britain, leading once again to thoughts of survival and continuity. Even when not depicting storms, Constable would often explore sites formerly viewed in tranquility with a new sense of vigour, as in a remarkable late sepia, *View on the Stour* (fig.60). It was as though the storm now lived inside him, informing his view of all.

60 [above]

View on the Stour: Dedham
Church in the Distance
c.1836
Graphite and iron-gall ink

on paper
20.5 × 16.9
Victoria and Albert
Museum, London

61 [opposite]
Cenotaph to the memory
of Sir Joshua Reynolds
erected in the grounds
of Coleorton Hall,
Leicestershire by the late

Sir George Beaumont, Bt.
1833–6
Oil paint on canvas
132 × 108.5
National Gallery, London

Constable's didactic interests were also evident in a series of lectures
on the history of landscape that he prepared at this time. Delivered
first at the Hampstead Literary Society in 1833, they were repeated at
Worcester and also at the Royal Institution. Doubtless he would have
liked them to have achieved the same central role as the Discourses of Sir
Joshua Reynolds. In many ways they can be seen as providing a revision
of academic theory similar to that which his paintings had offered to
academic practice. Unfortunately no full text survives. However, the
notes and sections that have been preserved make it clear that the series
was original and remarkable. It constituted the first serious history
of landscape painting ever penned. Its central thesis – that landscape
painting was as relevant to the present as history painting had been to
the Renaissance – was essentially the same as the one that Ruskin was to
develop in the first volume of *Modern Painters* a decade later.

Constable died suddenly at his house in Charlotte Street during the night
of 31 March– 1 April 1837, a book of the letters of William Cowper by his
side. Had he lived, he might well have fulfilled his ambition to publish his
lectures. As it happens, the summation of his views was left to a painting.
Cenotaph (fig.61) had been exhibited in 1836. Constable cannot have
known that this was the last time that he would exhibit alive. He was
probably most influenced in his choice of subject by the knowledge that
the work would be shown at the last exhibition that the Academy would
be holding in their old home of Somerset House before moving to new
quarters, shared with the National Gallery, in Trafalgar Square. They were
leaving the place Reynolds had secured for them, and it is Reynolds who is
commemorated in *Cenotaph*. The cenotaph represented was the one erected
by Sir George Beaumont on his estate at Coleorton in honour of Reynolds.
Constable had sketched it during his visit to Sir George in 1823. The rich
autumnal browns and 'picturesque' roughness of Constable's late style
seem to have a particular relevance here. However, the work is a challenge
as well as a memorial. For, by showing Reynolds in a natural setting, he is
relocating him. The flanking busts of the great Renaissance artists Raphael
and Michelangelo reinforce this point. Constable is in effect proclaiming
his belief that landscape had now inherited the mantle of the Old Masters.
As such, the picture can stand more appropriately as his own rather than as
Reynolds's epitaph.

10 EPILOGUE: ACHIEVEMENTS

AT THE TIME OF HIS DEATH, Constable's friends and supporters felt strongly that he had not received due recognition for his achievements. It was this that caused a group of them to purchase and present a picture by him to the National Gallery. As Leslie records in his *Life of John Constable*, they considered first the painting *Salisbury Cathedral from the Meadows* (fig.56) knowing it to be his preferred work. In the end, however, they settled on *The Cornfield* (fig.1), since they felt that this idyllic scene would recommend him more to the public, confirming his reputation as the faithful chronicler of the English countryside.

It is ironic that his friends should have sought to commemorate the artist in this way, since he himself had opposed the creating of a national gallery, arguing that should this happen 'there will be an end to the Art in poor old England, & she will become the same non entity as any other country which has one. The reason is both plain & certain. The manufacturers of pictures are then made the criterion of perfection & not nature.'[1] In a certain sense it could be argued that what Constable feared became true. The saccharine image of the countryside projected by *The Cornfield* has become accepted as a standard for representing English scenery, emulated by countless painters from the Victorian period to our own day.

Equally important for his reputation, however, was the publication in 1843 of Leslie's *Life*, which portrayed him as the 'martyr' of naturalism, adding a romantic story to the pre-existent idyllic image. This has enhanced his reputation as adherent to truth at all costs, the model painter of commitment.

It has also encouraged an oversimplified view of the artist that has cost him support. One of the most surprising opponents was the great Victorian critic John Ruskin. Given Ruskin's championship of landscape as the quintessential art of modern times, and his agreement with Constable about both the moral and scientific importance of 'truth to nature', it is surprising to find him taking such a dim view of the Suffolk painter's work. In *Modern Painters* he wrote of him:

> Unteachableness seems to have been a main feature of his character, and there is corresponding want of veneration in the way he approaches nature herself. His early education and associations were also against him; they induced in him a morbid preference of subjects of a low order … There is strange want of depth in the mind which has no pleasure in sunbeams but when piercing painfully through clouds, nor in foliage but when shaken by the wind, nor in light itself but when flickering, glistening, restless, and feeble.[2]

Ruskin's hero was Turner and his main aim in the first volume of *Modern Painters* (from which the above quote was taken) was to show how Turner's seemingly abstract inventions were in fact based on acute and penetrating perceptions of natural phenomena. Constable's less ambitious subject matter and more direct approach appeared to him naive by contrast.

It was probably Ruskin's low view of Constable's manner that encouraged his acolytes, the Pre-Raphaelites, to avoid his example when painting their own *plein-air* works. Indeed the obsessively detailed rendering of local scenery that they made under the rubric of 'truth to nature' underlines how varying even the most literal of records can be according to the different dispositions of the observers.

Meanwhile Constable's popularity was growing – in itself perhaps a sign of the increasing prevalence of a bourgeois taste for naturalism in the Victorian world. Despite Ruskin's opposition, there were many artists of the period – such as George Vicat Cole and Benjamin Williams Leader –

who painted rural idylls that could be seen as extensions of the ideology of *The Cornfield*. Although scorned by connoisseurs, they were the most popular landscapists of their day.

Constable's artistic – as opposed to his popular – reputation was redeemed by other means. It occurred largely through the championship of French artists and critics. The vogue for landscapes *à la Constable* had proved short-lived in Paris in the 1820s. However, he retained the respect of painters who continued to develop naturalism: first the Barbizon group, then the Realists, and finally the Impressionists. Constable maintained an honoured position in such circles both for his commitment to nature and for the pictorial challenge provided by his evocative yet vigorous ways of handling paint.

As Richard and Samuel Redgrave reported in their *Century of Painters of the English School* (1865):

> There can be no doubt that Constable had great influence on the landscape art, both of his own country and that of France, inducing much of that candid acceptance of nature, as contradistinguished from *compositions*, which some of the artists who succeeded him here, affect to follow even too minutely.[3]

Boosted by French support, Constable continued to provide an inspiration for British artists seeking to adapt the achievements of the Impressionists to an indigenous tradition, such as Philip Wilson Steer. The gift by Constable's daughter of the contents of his studio to the South Kensington (now Victoria and Albert) Museum further encouraged this direction. The bold sketches and studies that now emerged on public display presented a very different image of the artist to that familiar through such exhibition pieces as *The Cornfield* and *The Hay Wain*. Constable could be seen as an artist working boldly and experimentally before the motif and on a scale quite unprecedented at the time. He now looked like a genuine revolutionary.

While the official art world continued to favour Turner, with his rich range of themes and technical brilliance, the avant-garde looked more to Constable. He seemed to represent the thoughtful tradition of 'good painting' more completely. These were the terms in which the great Bloomsbury critic Roger Fry celebrated him in his *Reflections on British Art* (1934). 'Constable, like Gainsborough, belongs to the great European tradition of plastic design,' he

asserted. It was a claim he made about no other British artist. In his view, it was the failure of British artists to follow the lead offered by Constable that had led to their downfall in the Victorian age:

> How strange it seems when we consider how vast a future development Constable's work had suggested – how strange that when the young Pre-Raphaelites were trying to escape from the horrors of Victorian picture-making, some sketch of Constable's did not whisper that here was the way to a genuine and unexplored art. But here, as so often in our history, the rooted notion that the specific nature of pictorial design is not sufficiently imposing, that the feelings it alone can communicate are not sufficiently elevated and valuable to occupy the artist's utmost endeavours – that, in short, they must be poets at all costs – was the cause of their failure. With a little more clear thinking, a little more honesty and less pretension to a high calling, what an art we might have had![4]

Fry's lament was published in the 1930s, when naturalist painting was again falling out of favour. It seemed that the moment when Constable could have been generative for British art had passed for ever. The neo-romantic landscapists of the period looked back more to the fantasies of Turner and the visions of Samuel Palmer than they did to Constable's careful if passionate observation of the natural world. Yet that passion – which is so evident in the vigorous brushstrokes of his sketches – has fostered a respect for his work. In his magisterial survey *Landscape into Art* (1949) Kenneth Clark had some problems with the 'popular' Constable, but found the sketches richly rewarding: 'he is a bore only in his finished pictures. In his sketches the force of sensation is always strong enough to lift them above the commonplace.'[5]

Despite his conservatism, Constable's 'force of sensation' has given him a niche in Marxist studies. The great Marxist critic John Berger took a dim view of the Romanticism in Constable, which he saw as a form of evasion. He spoke of 'Constable's clouds formed by land and water we can't see'. Yet he nevertheless found an admirable substantiality in Constable's powerful engagement with light. He agrees with Constable's contemporaries that the finished works are better. He recognises that Constable 'didn't just tear leaves out of nature', and praises the interpretative force of his luminosity. 'The light in a Constable masterpiece is like water dripping off the gunwale of a boat as it drives through the sea. It suggests the way the whole scene is surging through the day, dipping through sun and cloud. By comparison the light of most other

62
Francis Bacon
Figure in a Landscape
1945
Oil paint on canvas
144.8 × 128.3
Tate

landscape painters is either like a fountain, playing prettily up and down for no purpose, or like water running flatly out of a tap.'[6]

For him the success and failure of Constable was the success and failure of Romanticism. In his review of the Council of Europe Romantic Exhibition of 1959 (from which the above quotation comes) he distinguished between the self-indulgence and escapism of the Romantics and the heroic commitment to integrity in the face of unpopularity, of which Constable was such a moving example:

> Leaving aside all that the Romantics did historically by establishing new subjects, they changed the nature of culture even for those who had no wish to follow them. They separated fervour from ambition. They questioned immediate success and success has never been quite the same since. Cézanne could never have borne the apparent failure of his life's work unless he had been sustained by the Romanticism he was working to overthrow.[7]

The reference to Cézanne is a telling one, for there are certain affinities between them. Both pursued a single track in the face of public indifference and both worked a local landscape with complexity and profundity, looking and recording with uncompromising honesty.

The sense of a fierce and complex record – so seemingly at odds with the image of the celebrator of the rural idyll – has remained the artist's most enduring contribution to painting. It is this that enabled him to be admired by the Abstract Expressionists and by that most complex of modern-day existential realists, Francis Bacon (fig.62). For Bacon, Constable was one of the very few historic English painters 'to be concerned with painting, that is with attempting to make idea and technique inseparable'.[8] The savagely worked sketch for *The Leaping Horse* in the Victoria and Albert Museum was a talisman for him.

Times have moved on yet again and Constable is nowadays more a subject for the historians than for artists and critics. Some – following the line set up by Sir Ernst Gombrich in his study of pictorial psychology *Art and Illusion*[9] – have developed a sense of the complexity of his vision. Others, such as Barrell and Rosenthal, have been keener to relate his imagery to its original social and political context; still others, like Stephen Daniels, to expose his largely posthumous role as a prime generator of the popular vision of England and symbol of national identity. There has also been the highly valuable new form of detailed connoisseurship supported by technical enquiry developed by Leslie Parris at the Tate and others that has enabled us to gain a far more precise understanding of Constable's manner and methods. This has made possible a more accurate identification of Constable's work, and separation of it from that by other hands – notably that by his son Lionel. All these lines of enquiry have been profitable. Nor do they necessarily contradict each other. Or perhaps I should say they form a contradiction only to the extent that there is a genuine contradiction within Constable himself. For he is at the same time a conservative and a revolutionary, a purveyor of myth and discoverer of truth. Similarly he is a person rooted in his period and someone who can take his place – as very few British artists can – in what Roger Fry called 'the great European tradition of plastic design'. Despite the seemingly focused nature of his art on a 'single path', Constable is no one thing. Rather than attempt to reduce him by taking just one of the many Constables that history has revealed it is surely better to consider them all, provided that we do not confound them with each other.

NOTES

INTRODUCTION:
IN CONSTABLE COUNTRY

1 R.B. Beckett (ed.), *John Constable's Correspondence*, I, 1962, p.235 (hereafter referred to as JCC; for full titles and publication dates of each volume, see Select Bibliography).
2 *At Home with Constable's Cornfield*, exhibition organised at the National Gallery, London, by Colin Painter, 1996.
3 Richard and Samuel Redgrave, *A Century of Painters of the English School* (first published 1865), 1890, p.340.
4 In *The Dark Side of the Landscape* (see Select Bibliography).
5 William Cobbett, *Rural Rides* (first published 1830), ed. George Woodcock, London 1967, p.206.

ROOTS: FAMILY AND EAST BERGHOLT

1 JCC, II, pp.17–18.

SEEKING A PATH

1 JCC, II, 1964, p.70.
2 JCC, III, p.111.
3 C.R. Leslie, *Memoirs of the Life of John Constable, R.A.*, (first published 1843), ed. Jonathon Mayne, London 1951, p.6.
4 Graham Reynolds, *Constable: The Natural Painter*, St Albans 1976, p.28.
5 JCC, II, p.16.
6 JCC, III, pp.27–8.
7 *The Diary of Joseph Farington, 1793–1821*, ed. Kenneth Garlick and Angus Macintyre (vols.I–VI), and Katherine

Cave (vols.VII–XVI), New Haven and London 1978–84.
8 JCC, II, p.32. Constable's use of the term 'painture' has long caused speculation. It is unclear whether it was a deliberate neologism or simply a slip of the pen. Leslie transcribed it in his book as 'painter', but modern commentators prefer the original, which may have been intended by Constable to refer to a particular type of painting.
9 Leslie 1951, p.18.

OUTDOOR WORK

1 Joshua Reynolds, *Discourses on Art*, ed. R. Wark, New York 1966, Discourse 2, p.36.
2 Constable to Maria, 27 May 1812: JCC, II, p.70.
3 For a discussion of gleaning practice see Christiana Payne, 'Boundless Harvests: Representations of Open Fields and Gleaning in Early Nineteenth Century England' in *Turner Studies*, vol.2, no.1, Summer 1991, pp.7–15.

'ANOTHER WORD FOR FEELING'

1 JCC, VI, p.82.
2 Maria to Constable, 22 June 1814; JCC, II, p.126.
3 Maria to Constable, Brighton, 15 Nov. 1814; JCC, II, pp.136–7.
4 Constable to Maria, 22 June 1812; JCC, II, p.78.
5 Constable to Maria, 22 June 1812; JCC, II, p.78.
6 Constable to Maria, 30 June 1813; JCC, II, p.110.
7 Constable to Maria, 28 Aug. 1814; JCC, II, p.131.
8 Leslie 1951, p.72.

THE LONDON PRACTICE

1 JCC, IV, p.228.

SIX-FOOTERS

2 JCC, II, p.271.
3 Leslie 1843, p.24; 1951, p.73.
4 The version of West's *Death on a Pale Horse* that Fisher was alluding to was probably that exhibited in 1817 and now in the Pennsylvania Academy of Fine Arts, Philadelphia.
5 To Fisher, 17 April 1822; JCC, II, p.275.
6 JCC, II, p.274.
7 JCC, VI, p.186.

EXPERIMENTS AND IDEAS

1 From Lecture IV, *John Constable's Discourses*, R.B. Beckett (ed.), Suffolk Record Society 1970, p.69.
2 JCC, VI, p.64.
3 JCC, VI, p.66.
4 Leslie 1951, p.282.
5 JCC, VI, p.74.
6 David Hill, *Constable's English Landscape Scenery*, London 1985, p.99.
7 To Fisher, 26 Aug. 1827; JCC, VI, p.231.
8 Leslie 1951, p.298.
9 To C.R. Leslie, 16 July 1834, JCC, III, p.111.
10 JCC, III, p.94.

STORMY WEATHER

1 JCC, I, p.252.
2 Asa Briggs, *The Age of Improvement 1783–1867*, London 1959, p.225.
3 To C.R. Leslie; JCC, III, p.49.
4 To Maria, 3 July 1814; JCC, II, p.127.
5 Now in Yale Center for British Art, New Haven.

6 Cobbett 1967, p.824

EPILOGUE: ACHIEVEMENTS
1 To Fisher, 6 Dec. 1822;
 JCC, VI, p.107.
2 Ruskin, *Modern Painters*, I,
 Part 2, sec.1, chap.vii, and §18,
 1843 (Waverley ed., I, p.95).
3 Redgrave 1890, pp.340–1.
4 Roger Fry, *Reflections
 on British Art*, London
 1934, pp.211–12.
5 Kenneth Clark, *Landscape
 into Art* (1949),
 Harmondsworth 1956, p.89.
6 John Berger, 'Romantic
 Notebooks', in *Selected
 Essays and Articles*,
 Harmondsworth 1972, p.97.
7 Ibid., pp.101–2.
8 This comment comes in an
 essay on Matthew Smith.
 See Francis Bacon, *Matthew
 Smith, a Painter's Tribute*,
 London 1953, p.12. Bacon's
 great interest in Constable is
 further attested by Norman
 Scarfe, Hon. General Editor
 at the Suffolk Record Society
 responsible for overseeing the
 production of Beckett's volumes
 of Constable's correspondence
 (see Select Bibliography). In a
 letter of 19 April 2002 to Anne
 Lyles, Curator of the Constable
 Collection at the Tate, Scarfe
 spoke of a meeting with Bacon
 in which he became aware of
 the artist's great devotion to
 Constable's work. 'Indeed he
 was amazingly familiar with
 it. Of course he knew Leslie's
 wonderful biography, but he also
 knew Beckett's vol. on Constable
 and the Fishers, the most
 touching and instructive of the
 whole mass of correspondence.
 But what was such a revelation
 was hearing Bacon talk about
 Constable's painting. I wished
 I'd had a tape recorder.'
 I am most grateful to Anne
 Lyles and Norman Scarfe for
 permission to quote this letter.
9 Ernst Gombrich, *Art
 and Illusion*, London
 1960, pp.29–34.

CHRONOLOGY

1776
Born on 11 June in East Bergholt, Suffolk, the son of a prosperous mill owner, Golding Constable. His mother, Ann Watts, is the daughter of a well-to-do London cooper.

C.1792
Starts work in his father's business while privately pursuing his ambition to be a painter. Is helped by John Dunthorne, a local glazier and part-time painter, who introduces him to the rudiments of the art.

1795
Meets the connoisseur Sir George Beaumont, whose mother lived nearby at Dedham. Receives encouragement from Beaumont.

1796
Meets the engraver and antiquarian J.T. Smith and makes drawings under his tutelage.

1799
Finally obtains permission from his father to train professionally as a painter. Comes to London with a letter of introduction to the Academician Joseph Farington, who becomes an important mentor for him. Enters the Royal Academy Schools as a probationer in March.

1800
Enrols as a student at the Royal Academy Schools on 19 February.

1802
Exhibits at the Royal Academy for the first time. After viewing the exhibition writes to John Dunthorne declaring 'there is room enough for a natural painture' and expressing his intention to return to Bergholt to make 'laborious studies from nature'. Spends the summer and autumn back in Bergholt, setting up a studio there which he uses intermittently for the next fourteen years.

1803–5
Divides time between London and Bergholt. Exhibits at the Academy, but attracts little attention. Paints portraits of locals. In 1805 he paints an altarpiece for Brantham Church.

1806
Exhibits a watercolour of the Battle of Trafalgar at the Royal Academy. Makes a two-month visit to the Lake District in the autumn, encouraged by his maternal uncle David Pyke Watts, a wealthy connoisseur. He exhibits Lake District scenes at the Royal Academy and British Institution over the next three years.

1809
In Bergholt he makes sketches which show a marked development

of a free and more expressive style. He seems at this point to have determined to return to making scenes of East Bergholt his principal artistic activity. In the autumn goes on local sketching trips with Maria Bicknell, the granddaughter of the vicar of East Bergholt, Dr Rhudde. Constable had known Maria since 1800, but it is only at this point that they fall in love.

1810
Paints an altarpiece for Nayland Church.

1811
Exhibits *Dedham Vale: Morning* (fig.24), his first major landscape, at the Academy. His attachment to Maria becomes known, but is discouraged by her family because of the disapproval of Dr Rhudde, from whom they hope to inherit. This leads to a protracted engagement lasting five years.

1812
First exhibits a view of Salisbury, the result of a stay in 1811 with the Bishop of Salisbury. Beginning of his close friendship with the Bishop's nephew, Archdeacon John Fisher.

1813
Exhibits *Landscape: Boys Fishing* at the Academy.

1814
Exhibits *Landscape: Ploughing Scene in Suffolk* at the Academy. When exhibited in 1815 at the British Institution it is bought by John Allnutt, a Clapham wine merchant. Constable set particular

store by this event as it was the first time that he had sold a picture to someone who did not know him personally. In this summer he made many sketches in Suffolk and Essex which were to form the basis of a large number of major pictures in the years to come. He also finished one or two pictures completely in the open air, notably *Boat-Building near Flatford Mill* (fig.27).

1815
Exhibits *Boat-Building* (fig.26) at the Academy. His mother dies in early March and he spends much time in Bergholt, where his father is seriously ill.

1816
Exhibits *The Wheatfield* (fig.28) at the Academy. His father dies in May and he comes into an inheritance sufficient to enable him to marry Maria, despite continued opposition from her family. His friend John Fisher officiates at their marriage, which takes place on 2 October at St Martin-in-the-Fields, London. After a honeymoon staying with Fisher and his wife in Dorset Constable and Maria settle permanently in London. Visits to Bergholt after this are rare.

1817
Exhibits four works at the Academy, including *Flatford Mill* (fig.30). First child, John Charles, born. The couple are to have seven children in all over the next eleven years.

1819
Exhibits *The White Horse* (fig.42) at the Academy, the first of his 'six-footer' canal scenes. Is elected

Associate of the Royal Academy on 1 November.

1820
Second canal scene, *Stratford Mill*, exhibited at the Academy. Stays with Fisher at Salisbury. In September settles with his wife and family in Hampstead on account of Maria's health, while maintaining a house and studio in Bloomsbury.

1821
Exhibits *The Hay Wain* (fig.2), the most famous of the canal scenes series. Begins a systematic study of skies.

1822
Fourth canal scene, *View on the Stour near Dedham*, exhibited at the Royal Academy, together with two views of Hampstead. Intensive programme of cloud studies at Hampstead. Moves into 35 Charlotte Street, the former house and studio of Farington, who had died in the previous year. This remains his principal residence for the rest of his life. Begins a connection with French dealer John Arrowsmith, who is to be instrumental in exhibiting *The Hay Wain* in Paris.

1823
Exhibits *Salisbury Cathedral from the Bishop's Grounds* (fig.57)at the Academy. Stays with Beaumont at Coleorton, making an intensive study of his collection of Old Master paintings.

1824
Exhibits canal scene *The Lock*. *The Hay Wain* exhibited to acclaim

in the Paris *Salon*. He is awarded a gold medal by the French Government. He takes his family to Brighton for the first time for reasons of Maria's health.

1825

Exhibits the last canal scene, *The Leaping Horse* (fig.46), at the Academy. *The White Horse* and one other work exhibited at Lille, where he receives another gold medal. He sells works in Paris through two French dealers. This source of income soon dries up, however.

1826

Exhibits *The Cornfield* (fig.1) at the Academy.

1827

Exhibits *Chain Pier, Brighton* at the Academy. Takes two of his children, John and Maria, to visit Bergholt. Takes the house in Well Walk, which is to be his Hampstead residence for the rest of his life.

1828

Birth of last child, Lionel, on 2 January. Lionel was to become in time an accomplished painter whose work has, until recently, often been confused with that of his father. Inherits a fortune from Maria's father. Maria's health declines and she dies at Hampstead on 23 November, at the age of forty-one.

1829

He is elected a full Academician on 10 February. Exhibits *Hadleigh Castle* at the Academy. Engages David Lucas to produce a series of mezzotints after his work. Entitled *Various Subjects of Landscape,*

Characteristic of English Scenery, from Pictures Painted by John Constable, R.A. (see fig.58), it has subsequently become commonly known as *English Landscape.*

1830

Is a member of the Academy hanging committee. First number of *English Landscape* is published.

1831

Exhibits *Salisbury Cathedral from the Meadows* (fig.56) at the Academy.

1832

Exhibits *Waterloo Bridge* at the Academy. Death of John Fisher on 25 August.

1833

Gives his first lecture on the history of landscape, to the history and scientific society at Hampstead.

1834

Exhibits watercolour of *Old Sarum* at the Academy. Visits Arundel and stays with Lord Egremont at Petworth.

1835

Exhibits *The Valley Farm* at the Academy.

1836

Exhibits *Cenotaph* (fig.61) at the last Academy exhibition to be held in Somerset House. Delivers his History of Landscape Painting series in their definitive form at the Royal Institution.

1837

Dies on 31 March. His *Arundel*

Mill and Castle is shown posthumously at the Academy.

ACKNOWLEDGEMENTS

I would like to thank Anne Lyles and Christiana Payne for their detailed and valuable comments on the manuscript for this book. Thanks too to Nicola Bion for instigating the commissioning of the work, to Gill Metcalfe for her assiduous picture research and to Judith Severne and Katherine Rose for their careful editing.

PHOTOGRAPHIC CREDITS

COPYRIGHT CREDITS

SELECT BIBLIOGRAPHY

C.R. Leslie, *Memoirs of the Life of John Constable, R.A.,* 1843. This work, written by a close friend of the artist, is irreplaceable as a biography

for its personal knowledge, insight and painstaking research. There have been many subsequent editions, the best one currently in print being that edited J.H. Mayne (Phaidon Press, London 1951).

R.B. Beckett (ed.), *John Constable's Correspondence*, Suffolk Record Society, 1962–70. Constable was a skilled and prolific letter writer. Beckett's edition of these constitutes the largest body of letters by any artist ever published. They provide an invaluable source not just for understanding Constable's art, but also for the knowledge they provide of the cultural and social life of London and Suffolk during the period. The individual volumes are as follows: *I: The Family at East Bergholt 1807–37* (1962); *II: Early Friends and Maria Bicknell (Mrs Constable)* (1964); *III: The Correspondence with C.R. Leslie* (1965); *IV: Patrons, Dealers and Fellow Artists* (1966); *V: Various Friends, with Charles Boner and the Artist's Children* (1967); *VI: The Fishers* (1968).

Also in the same series of publications by the Suffolk Record Society are:

R.B. Beckett (ed.), *John Constable's Discourses* (1970)
Leslie Parris, Conal Shields and Ian Fleming-Williams, *John Constable: Further Documents and Correspondence* (1975)

A full catalogue of Constable's oeuvre is published in:

Graham Reynolds, *The Early Paintings and Drawings of John Constable*, Yale University Press, New Haven and London 1995
Graham Reynolds, *The Later Paintings and Drawings of John Constable*, Yale University Press, New Haven and London 1984

Other important studies on or relating to aspects of Constable:

John Barrell, *The Dark Side of the Landscape*, Cambridge 1980
Ann Bermingham, *Landscape and Ideology: The English Rustic Tradition 1740–1860*, London 1987
Stephen Daniels, *Fields of Vision: Landscape Imagery and National Identity in England and the United States*, Cambridge 1994
Ian Fleming-Williams and Leslie Parris, *The Discovery of Constable*, London 1984
Andrew Hemingway, *Landscape imagery and urban culture in early nineteenth-century Britain*, Cambridge 1992
David Hill, *Constable's English Landscape Scenery*, London 1985
Judy Crosby Ivy, *Constable and the Critics*, Suffolk Record Society 1991
Leslie Parris, Conal Shields and Ian Fleming-Williams, *Constable: Paintings, Watercolours and Drawings*, exh. cat., Tate Gallery, London 1976
Leslie Parris and Ian Fleming-Williams, *Constable*, exh. cat., Tate Gallery, London 1991
Christiana Payne, *Toil and Plenty: images of the agricultural landscape in England, 1780–1890*, New Haven and London 1993
Graham Reynolds, *Constable: The Natural Painter*, St Albans 1976
Michael Rosenthal, *Constable, the Painter and his Landscape*, New Haven and London 1994
Andrew Shirley, *The Published Mezzotints of David Lucas after John Constable, R.A.*, Oxford 1930
John E. Thornes, *John Constable's Skies*, Birmingham 1999

INDEX